Treasured TEDDIES

Debbie Cole is a Certified Decorative Artist who has studied both decorative and fine art. She has studied fine art at numerous colleges throughout the United States. Her area of focus has been painting and design. Debbie is a self-taught artist who has been painting for 26 years. She has been teaching for 19 years and is an Ann Kingslan Accredited Teacher. She has taught intermediate and advanced classes at the Society of Decorative Painters Conventions for the past 15 years, and has taught numerous Intense Study classes at Heart of Ohio Tole convention. Debbie also travel teaches throughout the United States and has taught internationally in Canada, Argentina, and Japan.

You may contact Debbie and get information about her designs or seminars at Heaven Sent Publications, 14072 Birdsong Lane, Chino Hills, CA 91709, (909)627-2185. You can e-mail Debbie at debbie@debbiecole.com or visit her website at www.debbiecole.com.

DEDICATION

These designs are dedicated to my students and friends who have encouraged me over the years. Without your support, all that I do would not be possible. Thank you, and I hope that you will enjoy my designs for many more years to come.

ACKNOWLEDGMENTS

I also want to thank my Lord and Savior, Jesus Christ. All that I do comes from Him. *"Every good and perfect gift is from above, coming down from the Father of heavenly lights."* James 1:17

Table of Contents

Leilani 4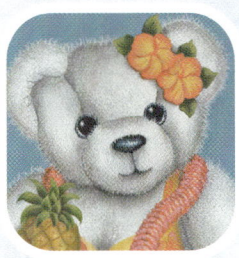

Angel 10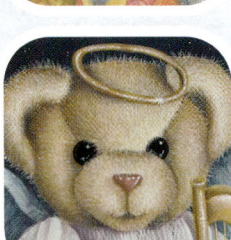

Barney 20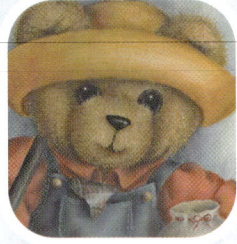

Holly 28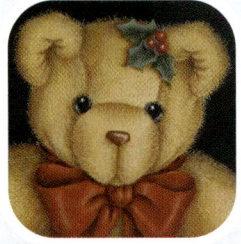

Davy 36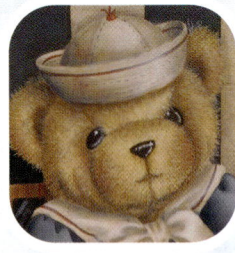

Rosie 48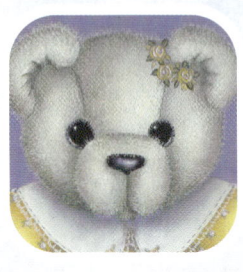

Pearl 56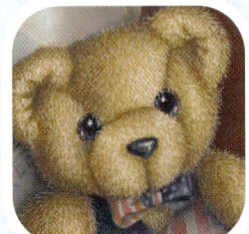

Sam 62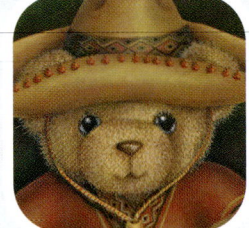

Carlos 74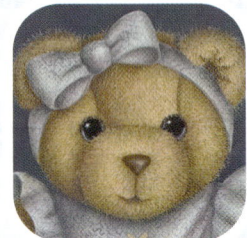

Belle 82

General Instructions 89

Paint Conversion Chart 93

Supplies

MISCELLANEOUS SUPPLIES

(Additional supplies needed to complete each project, including surfaces, are included with project instructions.)

You will need Delta Ceramcoat® Interior Matte Water Base Varnish, Delta Ceramcoat® All Purpose Sealer, Delta Ceramcoat® Color Float™, Delta Ceramcoat® Antiquing Gel, Delta Ceramcoat® Gel Blending Medium, Delta Ceramcoat® Faux Glaze Base, foam brush, brush cleaner, cellose sponge, sea sponge, disposable wax palette paper, graphite paper (white and black), old toothbrush, palette knife, paper towels, #2 pencil, sanding disc or paper, $5/8$"w Scotch Magic Tape, stylus, tack cloth, tracing paper, water tub, and wood filler.

PAINTS

(Paint colors used to complete each project are included with project instructions.)

- Delta Ceramcoat® Acrylic Paints

BRUSHES

(All of the following brushes are available through Heaven Sent Publications at www.debbiecole.com.)

- Silver Brush Ltd. Brushes
- The Debbie Cole Basic Sideload Set (includes three Golden Natural brushes) – Series 2008S Square Wash, sizes $3/4$" and $1/2$", Series 2002S Shader, size #6
- Cole Dry Brush – Series 2100S, sizes #0, 1, 2, 3, 4, 5, 6, and 8
- Cole Scruffy – Series 2101S, sizes #0, 2, 4, 6 and 8
- Golden Natural brushes – Series 2000S Round, size #3; Series 2007S Liner, sizes #0 and #00; Series 2024S Grass Comb, size $3/8$"

Leilani

Palette
Delta Ceramcoat® Acrylics: Antique Gold, Black, Black Green, Burgundy Rose, Butter Cream, Chrome Green Light, Dark Forest Green, Drizzle Grey, Fiesta Pink, Fruit Punch, Golden Brown, Light Ivory, Napthol Red Light, Ocean Reef Blue, Pink Parfait, Quaker Grey, Rain Grey, Raw Sienna, Storm Grey, Straw, Sunbright Yellow

Surface
8 1/2" x 10 3/4" Wooden Plaque

Wood Preparation and Basecoating
Read the General Instructions, pages 89-92, before you begin to paint. Prepare the surface as stated in "Wood Preparation," page 89. Basecoat the entire surface with Ocean Reef Blue + Rain Grey (1:1). Sand lightly, removing any brush strokes. Trace the design, page 8, onto tracing paper, then transfer design onto the center of the plaque. Use a ruler to keep the edges straight. Basecoat the bear with Quaker Grey; the lettering, flowers, bikini, and pineapple with Straw; the grass skirt with Black Green; and the leaves with Chrome Green Light. The pupils and nose are basecoated with Black. The lei will be stippled later. For now, simply add the lines to the surface. Outline the outer edges of the flower petals and lettering with thinned Fruit Punch. Use a very small brush to keep the lines very thin on the flowers. Line the bear's facial features with thinned Storm Grey in the same manner. The outside border will be added after the grass skirt is completed.

Painting Directions
Refer to the photos, pages 5 and 7, and the paint diagram, page 9, as you paint.

Bear
Dry brush the highlights with Drizzle Grey, varying the size of your Cole Dry Brush according to the area being painted. Dry brush the second highlights with Drizzle Grey + Butter Cream (2:1), covering a smaller area.

Stippling
(This bear is completed using my two-step stippling method.)

First Stippling: The first stippling colors are, from dark to light, Drizzle Grey, Drizzle Grey + Butter Cream (3:1), and Butter Cream + Drizzle Grey (1:1). Using a Cole Scruffy brush, begin adding texture by stippling very lightly. Vary the size of the brush according to the area being painted. Apply the color one value lighter than the area being worked. For example, in the dark areas, use Drizzle Grey. In the lightest areas use Butter Cream + Drizzle Grey (1:1). When stippling, use a very light touch, keeping the brush perpendicular to the painting surface. Work slowly so that all areas of the bear are covered.

Second Stippling: Once the first stippling is completed, move up in value and stipple again. Before going right over the first stippling with the new colors, wash over the fur with a light wash of Rain Grey. This will create a softer fur. The second stippling colors are Drizzle Grey + Butter Cream (3:1), Butter Cream + Drizzle Grey (1:1), and Light Ivory. Stipple one value lighter than the area being painted, just as the first stippling.

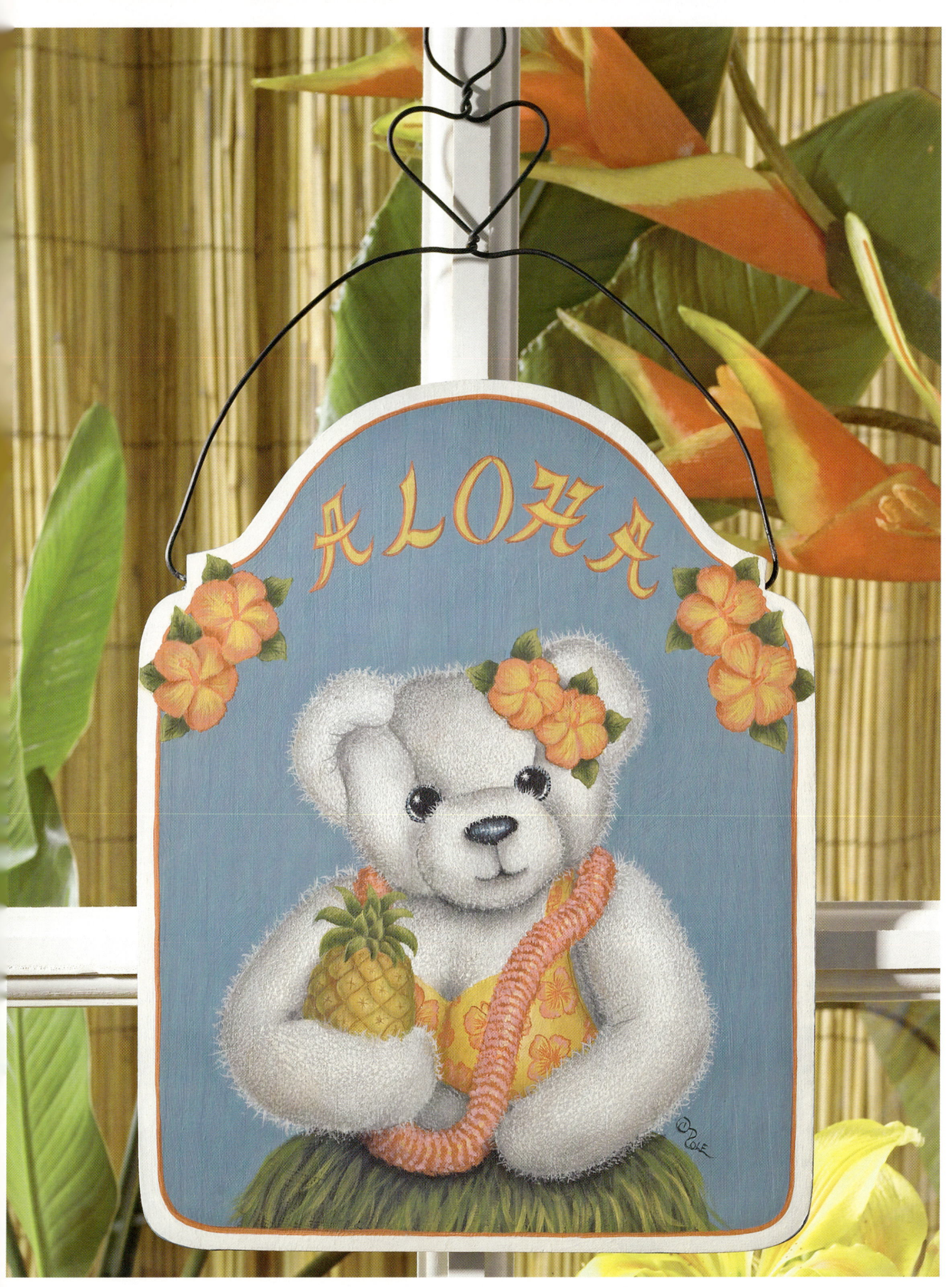

Glazing the Fur
Glaze the dark areas with Rain Grey. Glaze Storm Grey only in the darkest areas of the bear. Glaze Napthol Red Light as the accents.

Fur Texture
Using a #00 liner brush and thinned paint, add short criss-crossed hairs to the outside edges of the bear with Quaker Grey. These lines should be 1/8" long.

Eyes
Add a line of Ocean Reef Blue to the outside edges of the pupils to indicate the irises. Add Black horizontal lines over the irises. Float Rain Grey as the reflective lights in the eyes. Add Drizzle Grey dots as glints on top of these floated areas. Use Drizzle Grey to form small star-shaped glints in the upper left hand corners of the pupils. Add Light Ivory as the final glints in the middle of the stars.

Nose
Dry brush highlights with Ocean Reef Blue + Black (5:1). Dry brush the second highlights with Ocean Reef Blue. Add a final highlight of Ocean Reef Blue + Light Ivory (1:1).

Bikini
Dry brush the highlights with Sunbright Yellow. Add second highlights with Sunbright Yellow + Butter Cream (1:1). Float to shade with Antique Gold. Add the second shades, covering smaller areas, with Golden Brown. Touch up lines on the flowers with thinned Fruit Punch. Glaze the edges of the petals with Fiesta Pink. Reinforce the glaze with Fruit Punch. Glaze the darkest areas of the bikini with Raw Sienna.

Pineapple
Dry brush the highlights and float the shades using the same colors as the bikini. Add the lines with thinned Raw Sienna. Float next to the lines with Raw Sienna in the dark sections of the pineapple and Golden Brown in the lighter areas. Use very narrow floats. Glaze Chrome Green Light on both sides of the pineapple. Float Antique Gold as the reflective light on the left side of the pineapple.

Pineapple Leaves
Float to shade with Chrome Green Light + Dark Forest Green (1:1). Reinforce with floats of Dark Forest Green. Float to highlight with Chrome Green Light + Straw (1:1). Reinforce with floats of Straw. Glaze the darkest areas with Black Green.

Flowers
The flowers are painted in the same manner as the flowers on the bikini, with the exception that the colors are floated on instead of glazed. The stamens are basecoated with Fruit Punch and highlighted with Fiesta Pink. The clusters at the ends are stippled with Fruit Punch, then with Straw while the Fruit Punch is wet. The leaves are painted in the same manner as the pineapple leaves with the exception that the vein lines are pulled with lines of thinned Dark Forest Green.

Grass Skirt
Using a #2 or #3 round brush, pull lines to represent the blades of grass with Dark Forest Green. Add more blades with Dark Forest Green + Chrome Green Light (1:1), Chrome Green Light, and Chrome Green Light + Straw (1:1), covering a smaller area with each color change. If necessary, add just a few blades of Straw in the lightest area. Glaze Black Green at the top and the left side of the skirt.

Lei
Basecoat stipple the lei with Fruit Punch. Loading only half the brush with Fiesta Pink, add highlights using a #2 Cole Scruffy. Using a #0 Cole Scruffy, add more highlights with Pink Parfait. If necessary, add just a few highlights in the lightest area with Pink Parfait + Straw (1:1) using the tip of a #3 round brush. Glaze Burgundy Rose on the sides of the lei.

Finishing
The outside border is basecoated with Light Ivory. Outline the inside of the border with thinned Fruit Punch using a very thin line. Varnish as stated in "Varnishing," page 89.

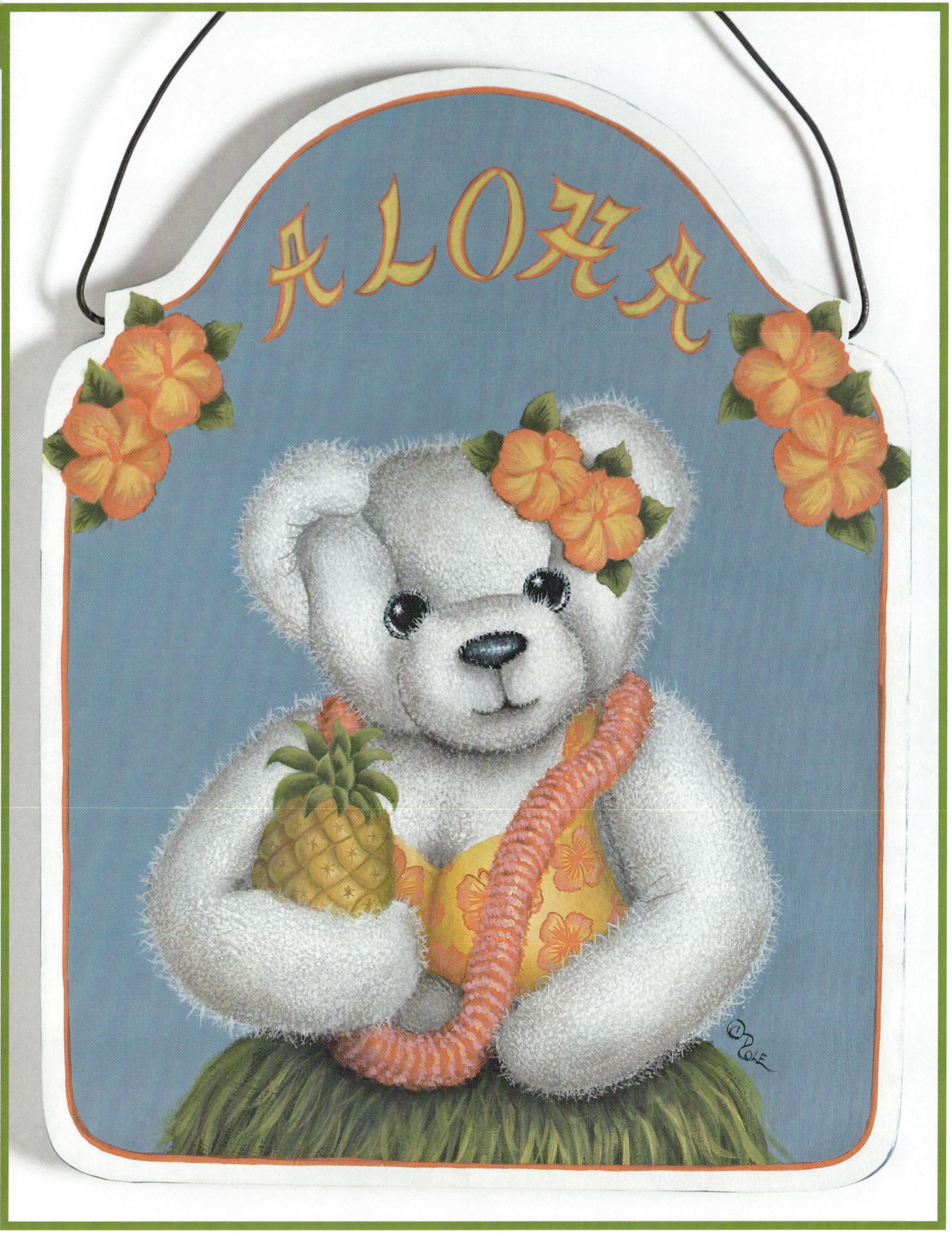

PATTERN

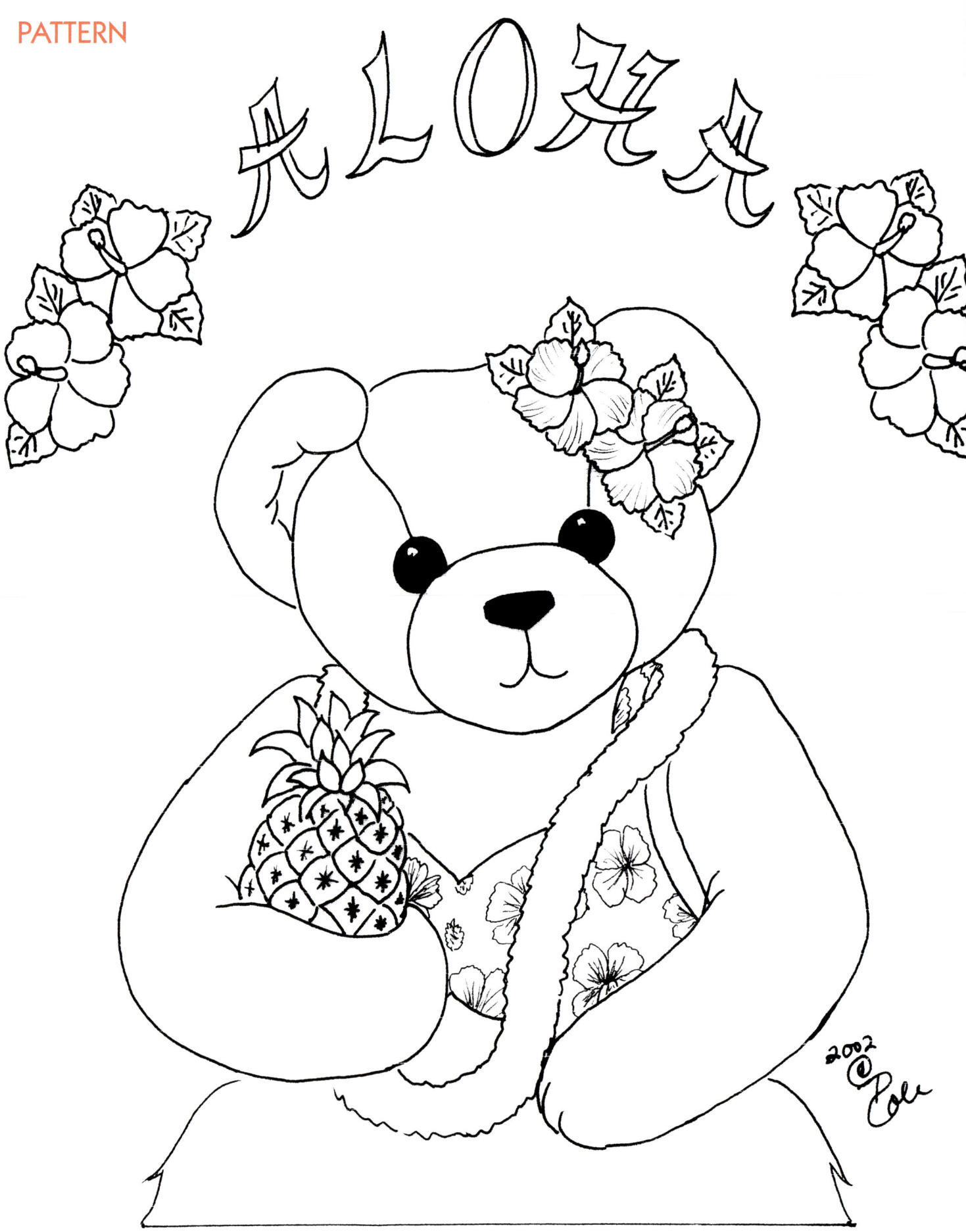

SHADE AND HIGHLIGHT PLACEMENT DIAGRAM

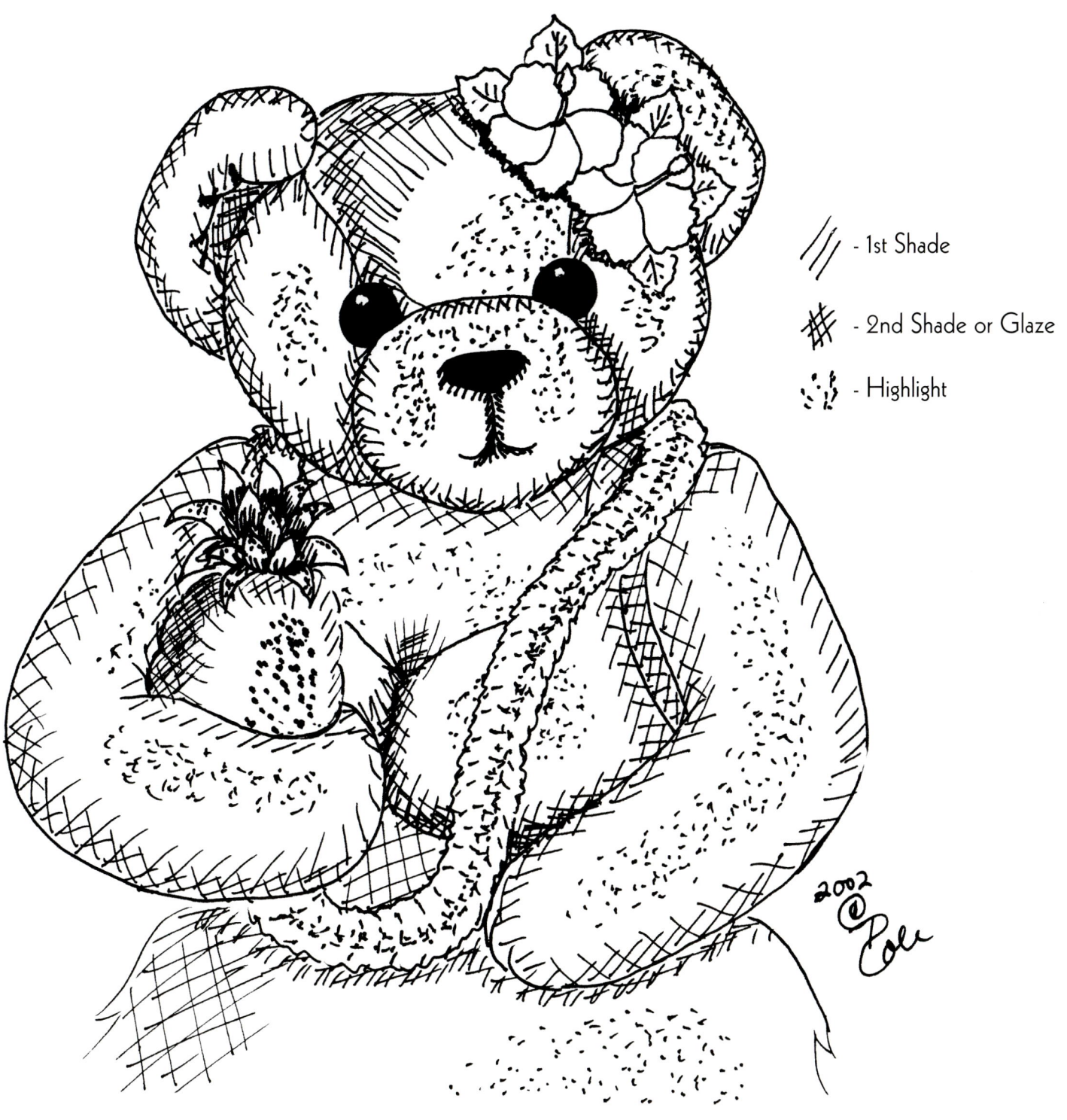

/// - 1st Shade

\# - 2nd Shade or Glaze

∴ - Highlight

Angel

Palette
Delta Ceramcoat® Acrylics: Antique White, Black, Dark Night Blue, Ivory, Maple Sugar Tan, Navy Blue, Old Parchment, Periwinkle Blue, Raw Sienna, Spice Brown, Straw, White, Wild Rose, Wisteria

Surface
$10^1/_2$" x $16^3/_4$" Wooden Oval Box

Additional Supplies
Plastic wrap

Wood Preparation and Basecoating
Read the General Instructions, pages 89-92, before you begin to paint. Prepare the surface as stated in "Wood Preparation," page 89. Trace the design, pages 16 and 17, onto tracing paper, then transfer the bear body only onto the center of the lid. Basecoat the background area with Dark Night Blue, going around the bear body. This will need two coats for an even coverage. Lightly splatter the background with a mixture of Maple Sugar Tan + Straw (1:1). Use a stylus to add a few bigger dots for stars. Basecoat the bear's body with Maple Sugar Tan. Apply enough coats to achieve a smooth even coverage. Transfer the bear's facial features, belly, paws, and leg lines onto the bear. Apply a thin line of Spice Brown to all these lines. Float to the right side of the belly and the leg lines with Spice Brown. Transfer the outer perimeter of the wings and the dress, including the sleeves and the bodice onto the bear. Do not include dress detail or ribbon lines at this time. Wash the dress with Wild Rose, being careful not to wash over the paws. Allow to dry and repeat. Wash the wings and the dress with Antique White. Allow to dry and repeat to wash the dress area with Antique White at least twice; I applied a light wash about four times to get the coverage I wanted. Remember to apply light washes, it's much better to have to repeat a step than to try to wipe off an entire area. Transfer all remaining lines, except the halo and the harp (they will be added after what's underneath is completed.) Basecoat the inner ears and the irises with Spice Brown. Basecoat the pupils with Black and the nose with Wild Rose. Basecoat the ribbon with Periwinkle Blue. Line the wing and the dress detail lines with Antique White.

Painting Directions
Refer to the photos, pages 11 and 13-15, and the paint diagrams, pages 17-19, as you paint.

Dress
Float and walk out the first shades with Wisteria + Wild Rose (3:1). Repeat these floats until a smooth even coverage is achieved. Float the second shades with Wisteria + Dark Night Blue (2:1), covering a smaller area. Float the last shades with Dark Night Blue in the darkest areas. Using a #8 or #6 Cole Dry Brush, dry brush the first highlights in the center of the dress with Antique White. Float and flip float the rest of the highlights on the dress with Antique White. Some of the first highlights will go right over the first shades. This is what makes the dress look transparent. Apply the second highlights with Antique White + White (1:1). Reinforce with a third highlight of White. For the center highlights, a flip float will be necessary. Use a #4 or #2 Cole Dry Brush for dry brushing highlights in smaller areas. Line the smocking on the dress bodice with Antique White. Highlight the smocking line work with White.

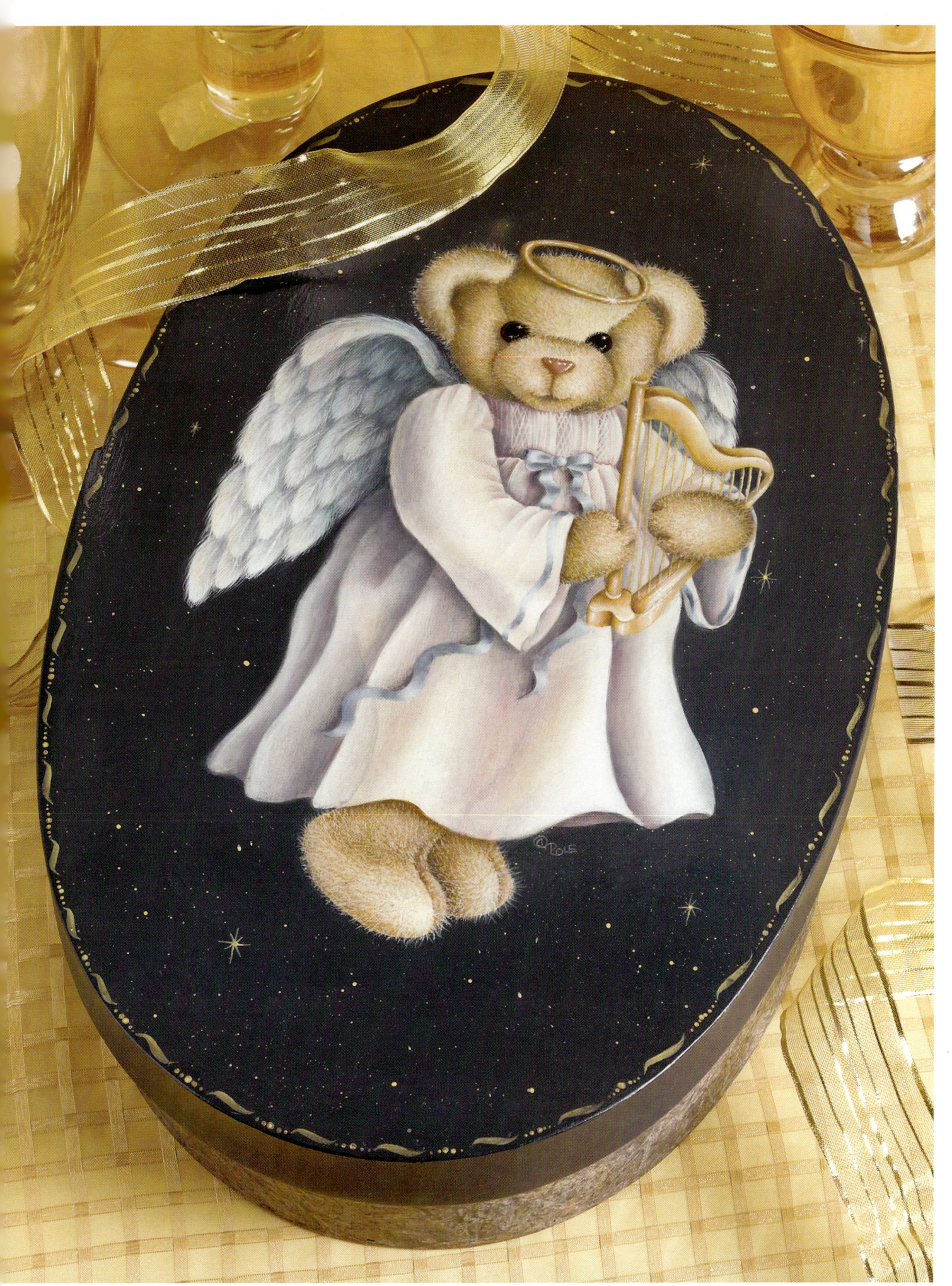

Ribbon

Float the first shades with Periwinkle Blue + Dark Night Blue (2:1). Repeat if necessary. Add a second shade in the same manner with Dark Night Blue. Float or flip float the first highlights with Periwinkle Blue + Antique White (2:1). Reinforce highlights with Antique White.

Wings

Float to highlight tips of wings using Antique White. Using the comb brush, add the texture to the wings with Antique White. Load the brush, then curve the lines as you pull away from the center line. Apply Wild Rose and Maple Sugar Tan glazes to the highlighted areas of the wings and Navy Blue glazes to the shaded areas of the wings. Wash over the entire wings with a wash of White. While this is wet, walk out a wash of Navy Blue in the shaded areas. Reinforce and fill in more texture on the feathers using a liner brush and thinned White paint. Glaze in more shades of Dark Night Blue in the darkest areas and to separate the feathers, if necessary.

Bear

Dry brush or float the first shades with Raw Sienna, using a #6 or #4 Cole Dry Brush. Add the second shades in the same manner with Spice Brown. Dry brush the highlights with Old Parchment.

Stippling

The stippling colors are, from dark to light, Maple Sugar Tan, Old Parchment, and Ivory. Stipple the bear using Maple Sugar Tan in the darkest areas, Old Parchment in the middle value areas, and Ivory in the lightest areas. Antique White may be used in the lightest areas if the Ivory does not show up. Vary the size of the Cole Scruffy Brush according to the area being stippled.

Ears

Wash the inner ears with Dark Night Blue.

Eyes and Nose

Touch up eyes and nose, if necessary, with the basecoat colors. To complete the eyes, line around the outside of the eyes with Black. Pull very thin Black lines around the irises of the eyes. Add the highlights with Antique White, reinforcing with White in the brightest highlight areas. Shade the nose with Spice Brown. Apply the highlights just the same as the eyes.

Fur Texture

Line the fur using, from light to dark, Maple Sugar Tan, Old Parchment, Ivory, and Antique White. Reinforce any shaded areas that need more depth with a very light float of Spice Brown.

Glazing the Fur

Glaze the fur with Wild Rose and Dark Night Blue, referring to the shade placement diagram, page 18. Keep these very transparent so that the texture will show through.

Halo and Harp

Transfer the halo onto the bear after the stippling is completed. Transfer the harp onto the bear after the dress is completed. Basecoat halo and harp with Maple Sugar Tan + Straw (1:1). Use a straight edge to trace on the harp's strings, then line them with the basecoat color. Float Raw Sienna as the first shades and Old Parchment as the first highlights using as small a brush as possible. Reinforce with a second shade of Spice Brown and a second highlight of Ivory. Add final glints of White. Glaze the last shades with Dark Night Blue only in the darkest areas.

Bottom of Box

Basecoat the entire bottom of the box with Wild Rose. The faux finish is completed in the following steps, allowing each step to dry before going on to the next step. When working with washes, you must work very quickly. If this is too difficult, use an extender to thin the paint instead of water. This will extend the open time, but will delay the drying time. Apply a wash of Maple Sugar Tan + Straw (1:1) to the sides of the bottom of the box. Lay a piece of plastic wrap down on the box, covering the wash. Scrunch up the plastic and lift it off. Allow to dry. Repeat to apply a wash of White just as above. Finally, apply a wash of Dark Night Blue just as above.

Finishing

Apply the large stars by pulling very thin lines of Maple Sugar Tan + Straw (1:1) around some of the large dots to form the stars. Do not make too many of these because it will make the background too busy. Apply "S" strokes of Maple Sugar Tan + Straw (1:1) around the outside perimeter of the lid to form the border. When completely dry, lightly wash over this border with the background color. Varnish as stated in "Varnishing," page 89.

14

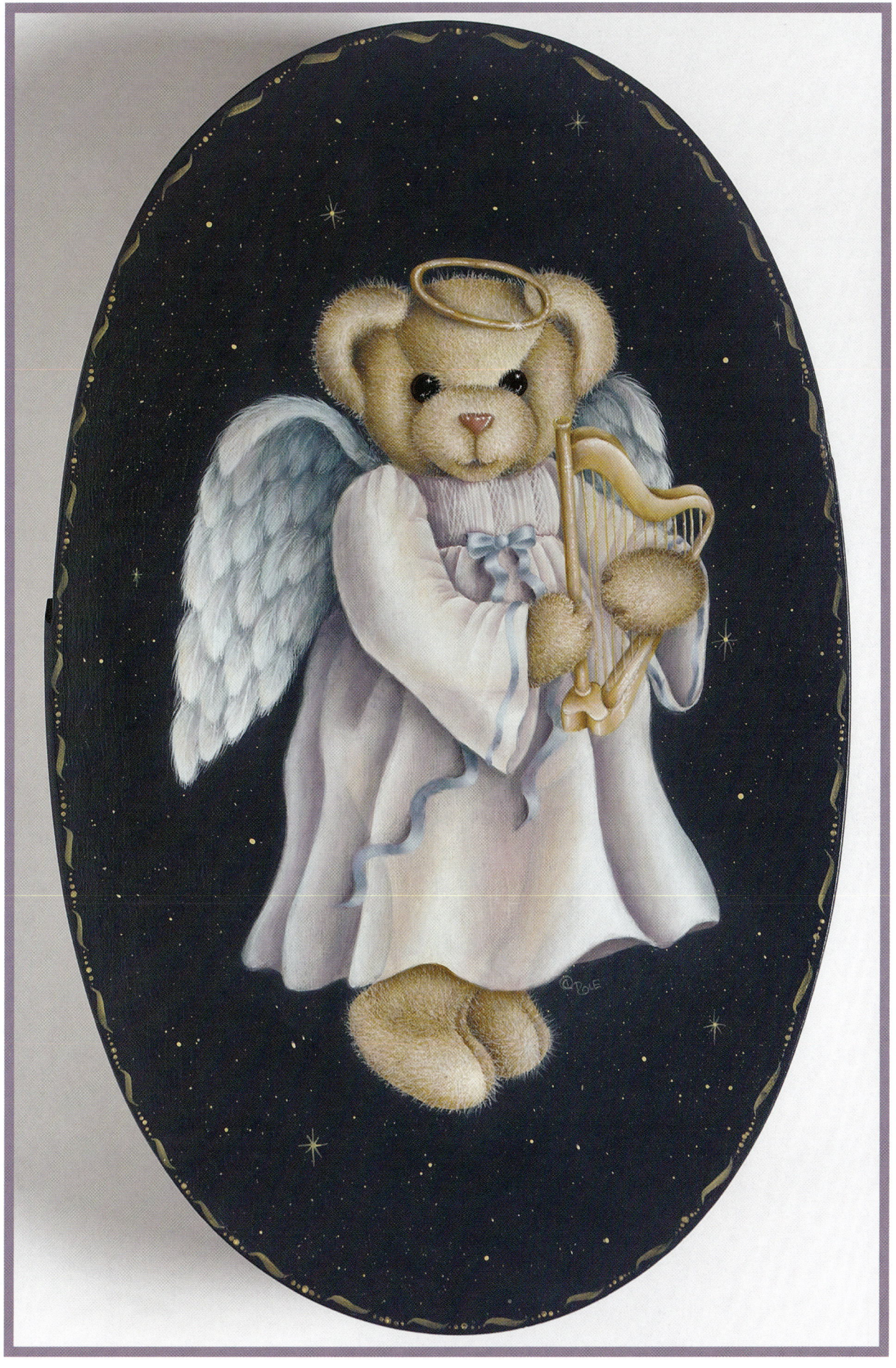

PATTERN

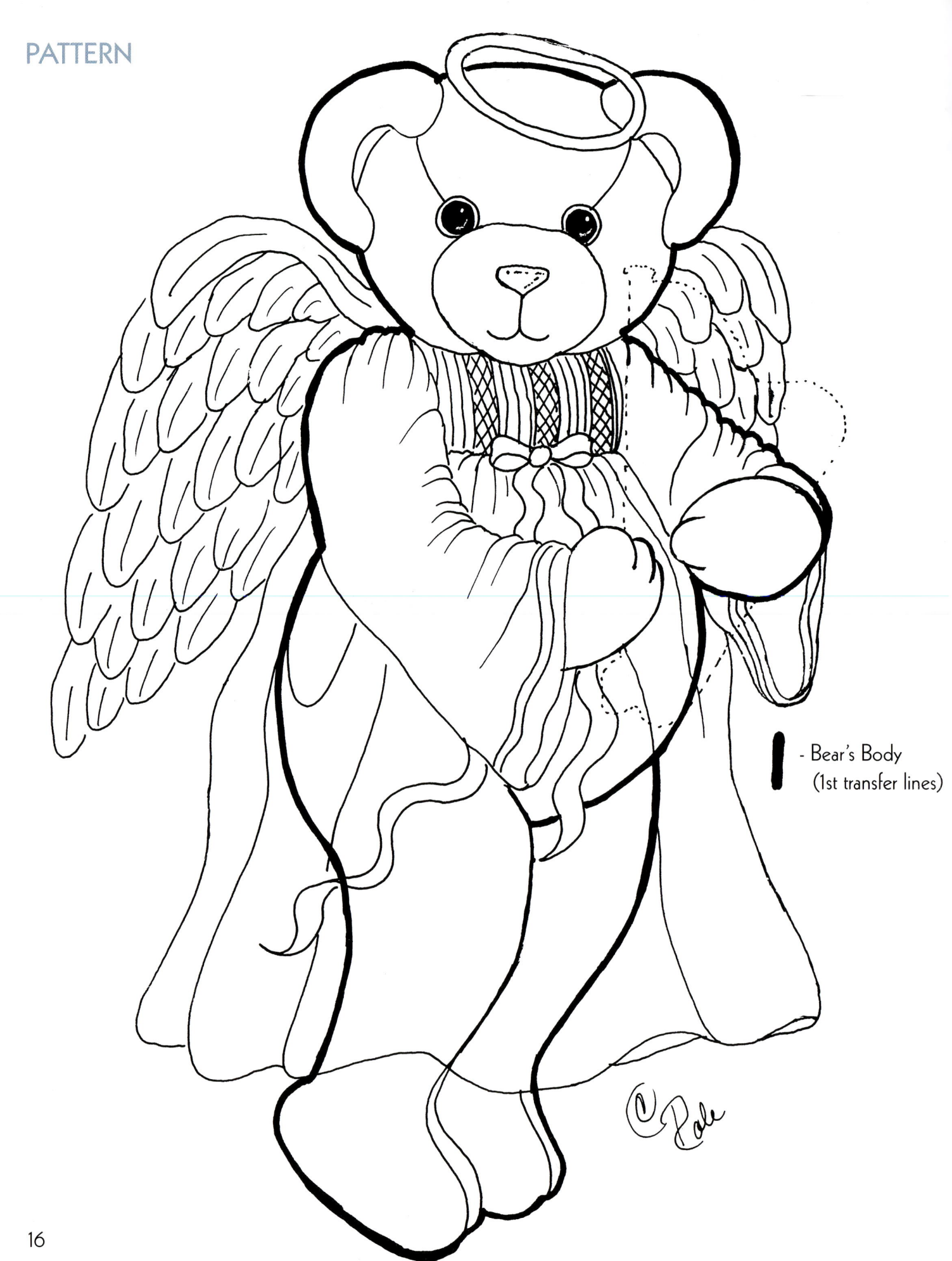

▬ - Bear's Body
(1st transfer lines)

16

PATTERN

SHADE PLACEMENT DIAGRAM

•••• - Dark Night Glazes
//// - Shades
▧▧▧ - 2nd Shades

SHADE PLACEMENT DIAGRAM

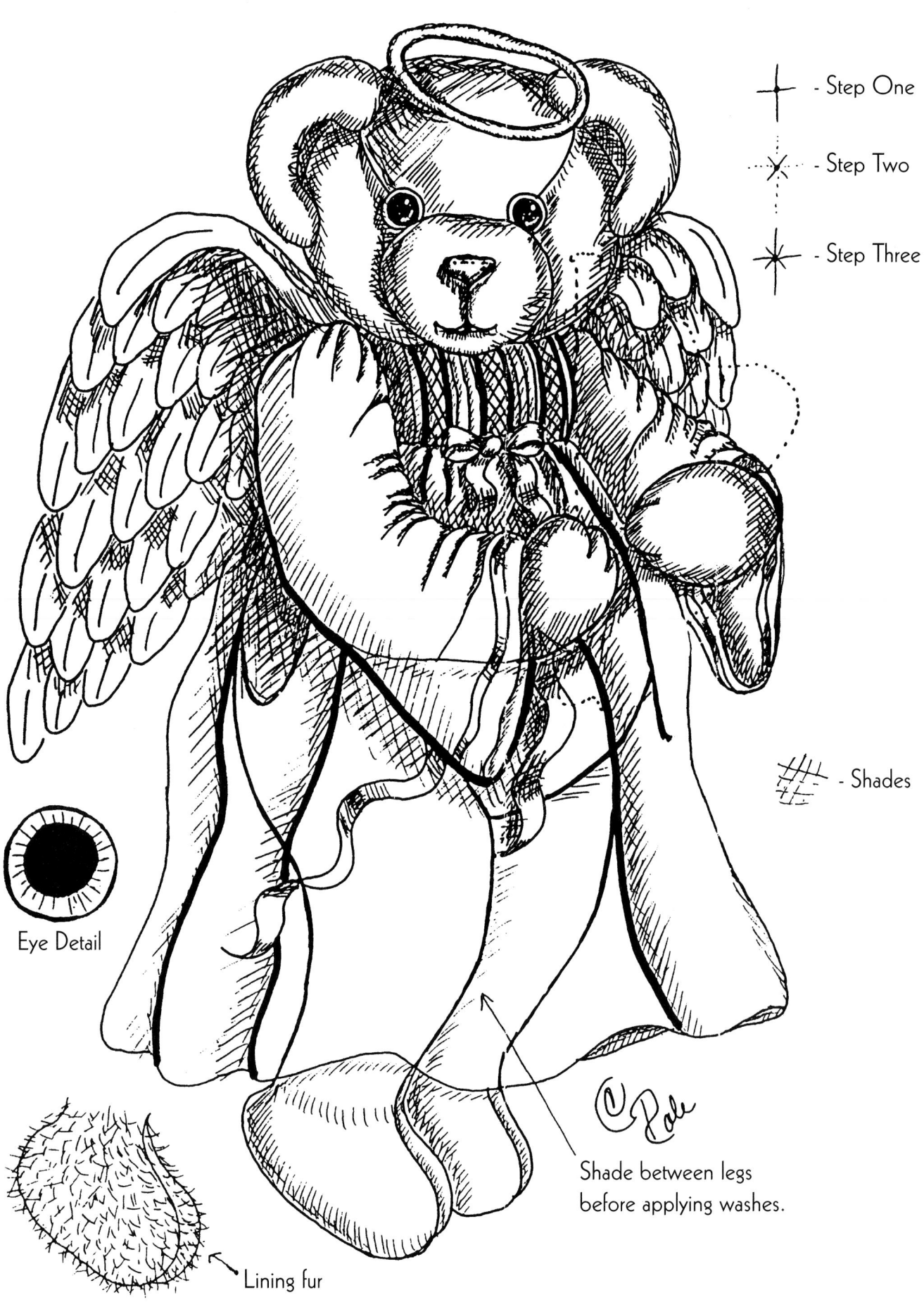

- Step One
- Step Two
- Step Three
- Shades

Eye Detail

Lining fur

Shade between legs before applying washes.

HIGHLIGHT AND ACCENT PLACEMENT DIAGRAM

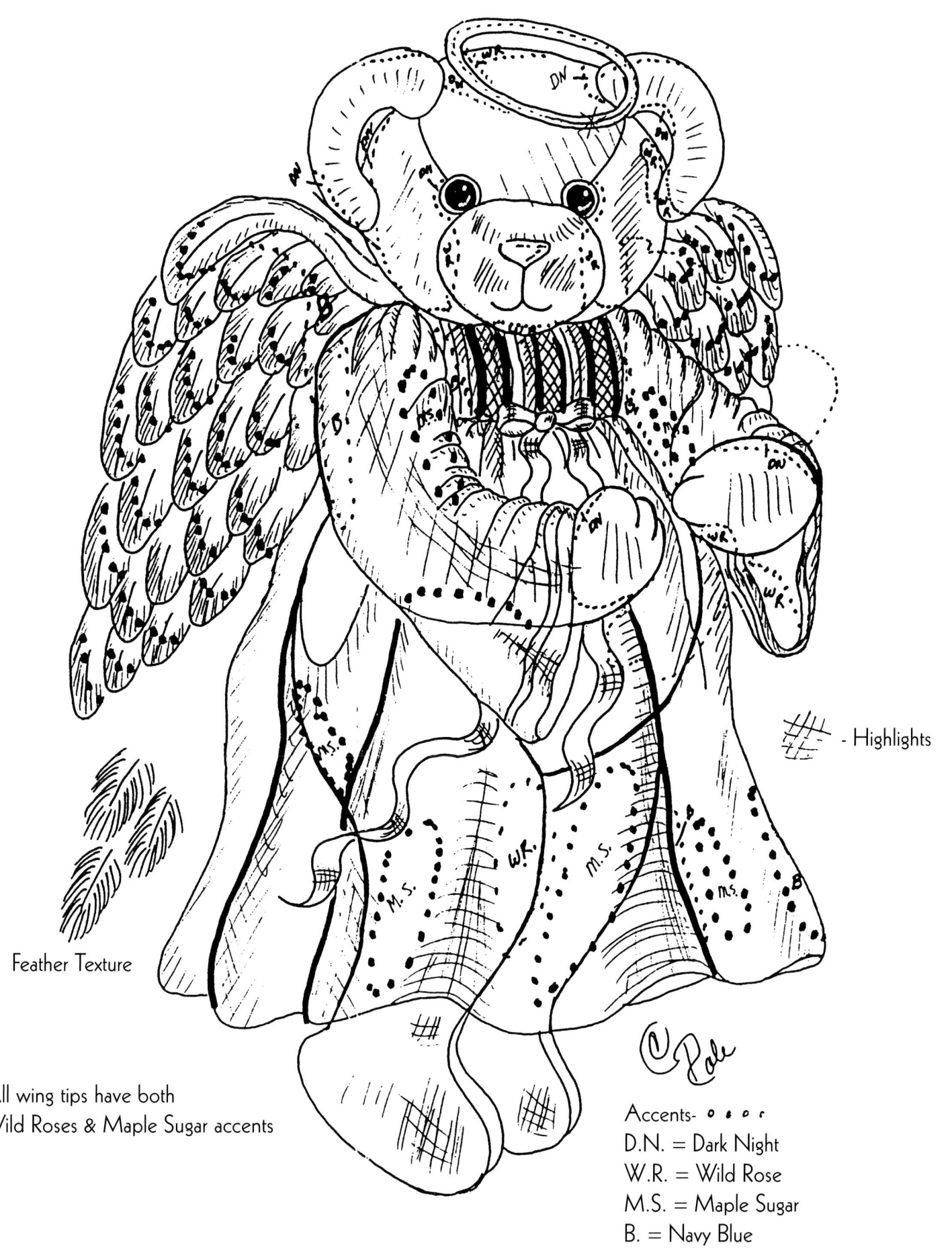

- Highlights

Feather Texture

All wing tips have both
Wild Roses & Maple Sugar accents

Accents-
D.N. = Dark Night
W.R. = Wild Rose
M.S. = Maple Sugar
B. = Navy Blue

Barney

Palette
Delta Ceramcoat® Acrylics: Adobe Red, Antique White, Black, Burnt Umber, Cape Cod Blue, Cinnamon, Coral, Dark Night Blue, Dolphin Grey, Forest Green, Golden Brown, Hippo Grey, Maple Sugar Tan, Mudstone, Nightfall Blue, Old Parchment, Pine Green, Raw Sienna, Red Iron Oxide, Rouge, Sandstone, Spice Brown, Spice Tan, Straw

Surface
$10^{3}/_{8}$"h x $9^{1}/_{2}$" dia. Wooden Bucket

Wood Preparation and Basecoating
Read the General Instructions, pages 89-92, before you begin to paint. Prepare the surface as stated in "Wood Preparation," page 89. Wash the outside of the bucket with Antique White twice, then add a third wash over the area using Dolphin Grey. Wash the ground with Burnt Umber, then wash over it again with Forest Green. Add the grass using lines of Forest Green and Pine Green. Basecoat the top rim and inside of the bucket with Nightfall Blue. Add a line of Adobe Red + Red Iron Oxide (1:1) under the blue rim. Trace the design, page 26, onto tracing paper, then transfer on the basic design, excluding the details, onto the bucket. Basecoat the shirt, bucket, and pot with Adobe Red; the watering can and chick with Golden Brown + Straw (1:1); the hat with Straw; the bear and dirt with Spice Brown + Straw (1:1); the cuffs, bag, hoe blade, and handkerchief with Mudstone; the pants with Cape Cod Blue + Hippo Grey (4:1); and the hoe handle with Hippo Grey + Mudstone (1:1). Add details to the bear and basecoat the irises with Burnt Umber and the pupils and nose with Black.

Painting Directions
Refer to the photos, pages 21 and 24-25, and the paint diagram, page 27, as you paint.

Background
Float in the dark areas with Dolphin Grey, Cape Cod Blue, then Nightfall Blue.

Ground
Float the dark areas with Forest Green, Pine Green, then add the darkest areas with a glaze of Dark Night Blue.

Shirt, Pot, and Bucket
Shirt
Dry brush the first highlights with Rouge + Coral (5:1) on the center of the sleeves. Float the first highlights on the rest of the shirt. Remember to repeat each step until a smooth even coverage is created. Dry brush the second highlights with Rouge + Coral (3:1), covering a smaller area. The smallest highlights are dry brushed with Coral + Rouge (1:1). Float and/or dry brush the shades. The first shades are Red Iron Oxide. The second shades are Cinnamon. Glaze the last shades with Dark Night Blue.

Pot and Bucket
Float and walk out the first and second shades using the same colors as the shirt. Glaze on the last shade. Float and flip float the highlights using the same colors as the shirt. Add the rim and handle to the watering can with lines of Hippo Grey. Highlight these lines with Mudstone, then Sandstone, by either floating or using a liner brush to line them in. Float over the shaded areas with a glaze of Black. Stipple the rust with Raw Sienna + Adobe Red (2:1), then with Spice Brown, and finally with Burnt Umber, covering a smaller area with each color. The bucket has a final glint of Coral flip floated in the brightest area of the highlight.

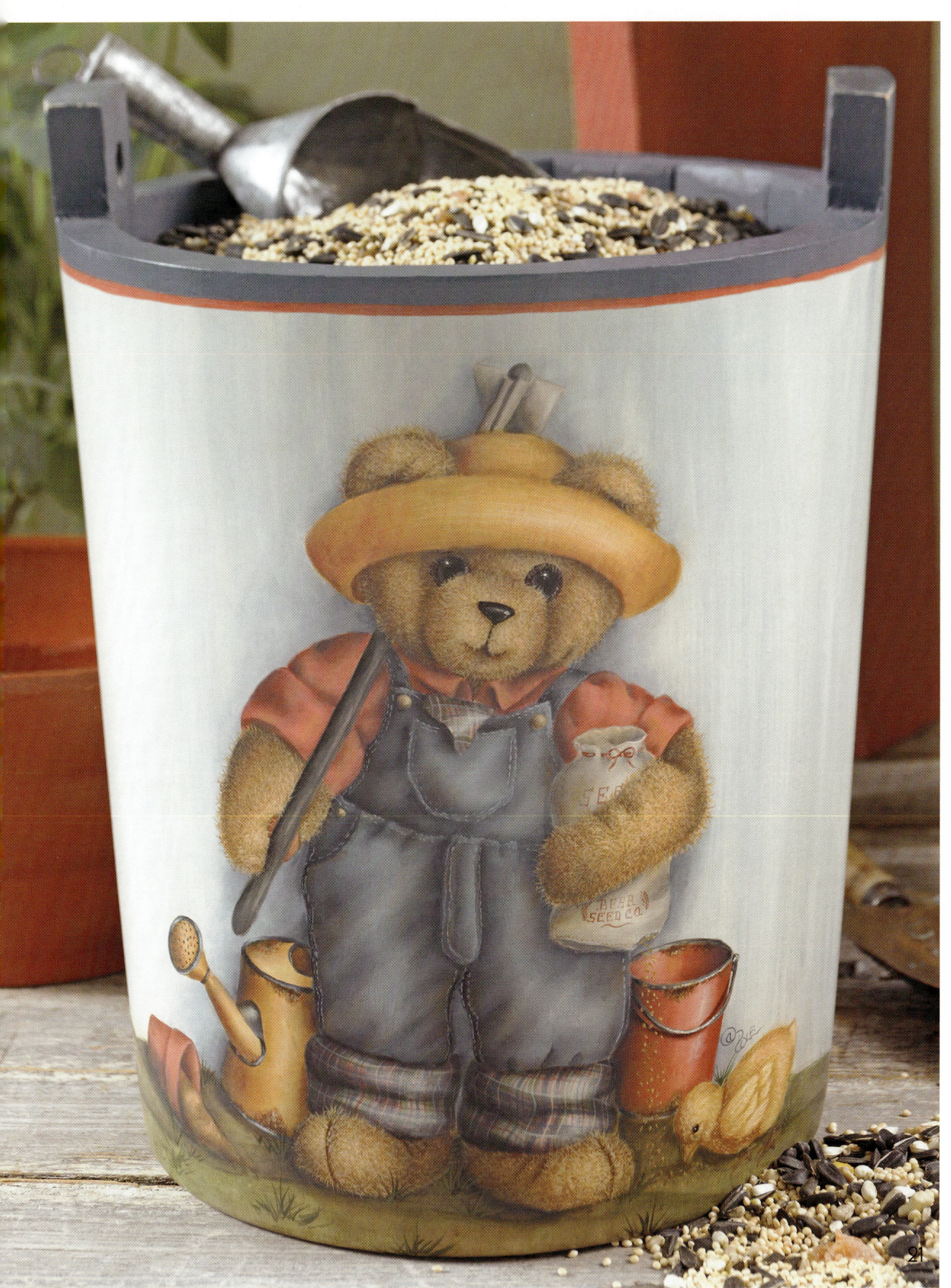

Watering Can and Chick

Watering Can

Float all the first shades with Golden Brown. Add the second shades in the same manner with Spice Brown. The highlights are flip floated using Straw + Maple Sugar Tan (1:1), reinforced with Maple Sugar Tan + Straw (2:1). Add the details to the can. The trim is Nightfall Blue. Highlight this with Cape Cod Blue, then Dolphin Grey. Shade with Dark Night Blue. The holes in the spout are Black with Mudstone highlights on the left side of each hole. Glaze Dark Night Blue in the darkest areas of the can. Glaze Red Iron Oxide accents where indicated on the diagram. Add rust in the same manner as the bucket.

Chick

Dry brush the highlights where necessary using the same colors as the watering can. Float to shade using the same colors as the watering can. Stipple the chick very lightly with Straw in the dark areas and Maple Sugar Tan in the light areas. Add texture lines using the same colors. Use Maple Sugar Tan + Old Parchment (2:1) to add texture lines in the lightest areas. Refer to the bear's fur instructions. Add the eye with Dark Night Blue. Highlight with a dot of Mudstone. Glaze Red Iron Oxide as the accents. The feet are basecoated with Golden Brown. Shade the feet with Spice Brown and highlight with Golden Brown + Straw (2:1).

Overalls

Float in all the shades around the edges, repeating until they have an even coverage. Then dry brush some of the shades towards the center areas, beginning with the folds in the pants. The first shades are Nightfall Blue + Hippo Grey (3:1), the second shades are Dark Night Blue + Hippo Grey (3:1), and the third shades are Dark Night Blue + Black (3:1). Most of the highlights are dry brushed, but float those by the edges. Repeat highlights multiple times until you achieve the desired look. The first highlights are Cape Cod Blue + Mudstone (2:1) and the second highlights are Dolphin Grey. Add the stitching with Cape Cod Blue in the dark areas and Dolphin Grey in the light areas. Glaze Spice Brown accents referring to the diagram for proper placement. Add the buttons with Golden Brown. Shade buttons with Spice Brown. Highlight buttons with Straw, then reinforce with Maple Sugar Tan.

Bear

Transfer all the bear features onto the bear. Line them with Burnt Umber. Float to shade the bear with Spice Brown + Straw (2:1). Reinforce the shades with Spice Brown, then with Burnt Umber + Spice Brown (1:1) in the darkest areas only. Dry brush and/or float the highlights with Spice Tan.

Stippling the Bear

The stippling colors are, from dark to light, Raw Sienna, Raw Sienna + Spice Tan (1:1), Spice Tan, and Spice Tan + Maple Sugar Tan (1:1). After stippling, wash the bear with a thin wash of Spice Brown to help the bear look softer.

Eyes and Nose

Touch up the eyes and nose, if necessary, with the basecoat colors. Line the outside of the irises very thinly with Black. Add little lines going all around the irises; refer to the enlarged eye diagram. Float to the left and to the right sides of the pupils with Nightfall Blue + Hippo Grey (2:1). Use the same color to float on the nose. Use Mudstone to tap in a few dots on top of these floats. Also, using Mudstone, line a star shape in the upper left corners of the pupils. Place a final glint in the center of the star shapes using Antique White.

Fur Texture
Line the fur using, from dark to light, Raw Sienna + Spice Tan (1:1), Spice Tan, Spice Tan + Maple Sugar Tan (1:1), and Maple Sugar Tan. After lining the fur, wash over the bear with a thin wash of Spice Brown.

Glazing the Fur
Glaze Burnt Umber, using a very transparent color, in the darkest areas on the bear. Then glaze Dark Night Blue in the same areas. Glaze Red Iron Oxide accents on the bear. After glazing the fur, wash over the pads with a wash of Red Iron Oxide, then float the same color in the shaded areas.

Dirt
Float to shade and dry brush to highlight using the same colors as the bear.

Cuffs, Bag, Hoe Blade, and Handkerchief
Float all the shades. The first shades are Mudstone + Hippo Grey (2:1) and the second shades are Hippo Grey. Dry brush or float the highlights. The first highlights are Mudstone + Sandstone (1:1) and the second highlights are Sandstone. Add the plaid to the cuffs and handkerchief using washes of Adobe Red and Forest Green, then add lines of Nightfall Blue and Antique White over the washed areas. Glaze in Dark Night Blue in the darkest areas. Dry brush Sandstone highlights over the plaid areas. Add Adobe Red lettering to the bag. Also, glaze Raw Sienna accents onto the bag. The stitches are Mudstone.

Hat
Float and walk out the shades. The first shades are Golden Brown and the second shades are Raw Sienna + Spice Brown (2:1). The highlights will need to be flip floated and walked out. The first highlights are Straw + Maple Sugar Tan (2:1) and the second highlights are Maple Sugar Tan + Straw (1:1). Line in some texture lines vertically, then horizontally using Golden Brown in the darkest areas, Straw in the middle areas, and Maple Sugar Tan in the lightest areas. Keep these lines very thin. After this is completed, float the second colors again. Glaze Burnt Umber in the darkest areas of the hat. Add Red Iron Oxide accents to the hat.

Hoe Handle
Using the chisel edge of the 1/4" flat brush, chisel in Mudstone for the wood grain. Float the edges with Hippo Grey, reinforcing the left side with Hippo Grey + Black (4:1). Flip float the highlights with Mudstone + Sandstone (1:1).

Finishing
Add the seeds with dots of Golden Brown. Highlight the seeds with Straw. Varnish as stated in "Varnishing," page 89.

24

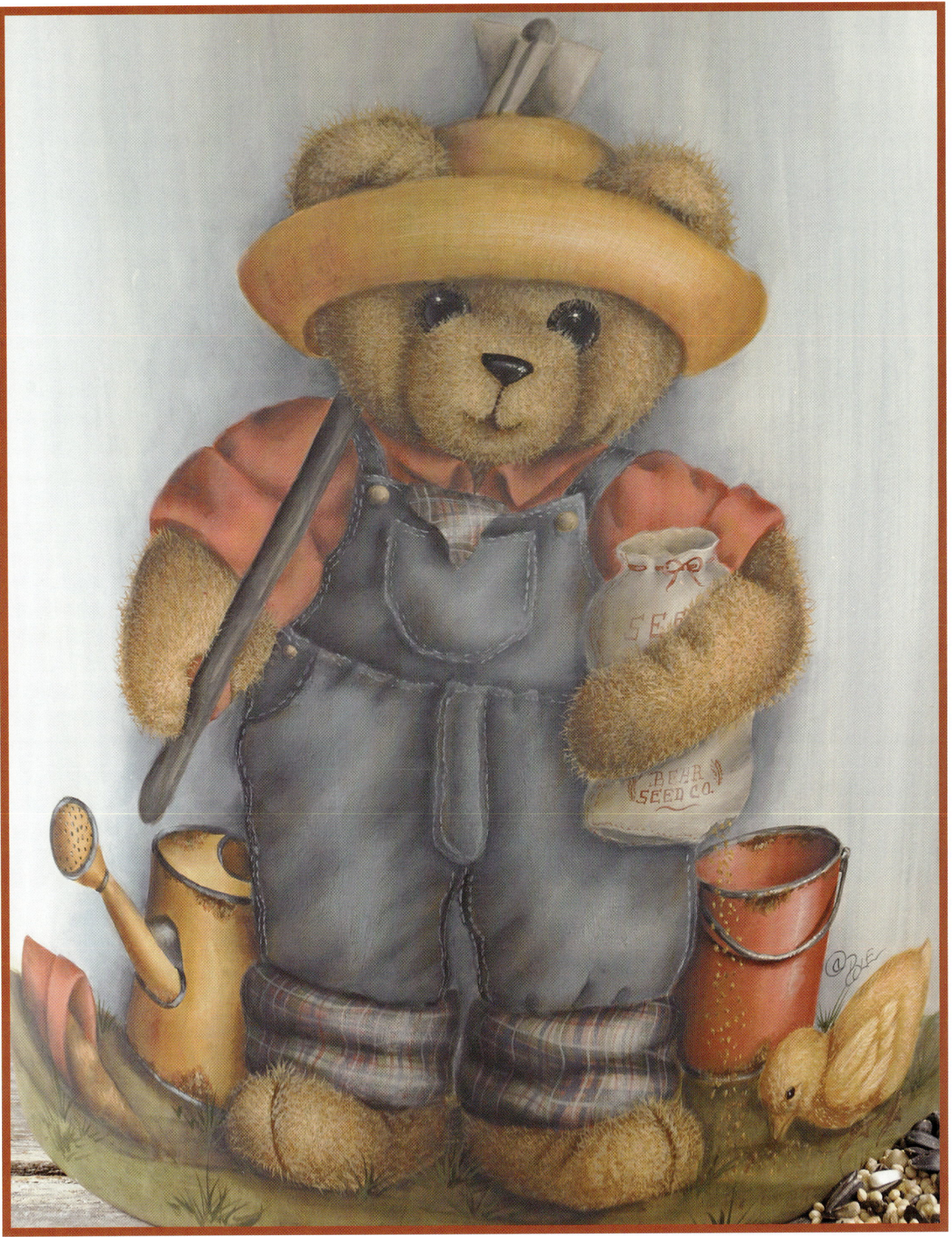

PATTERN

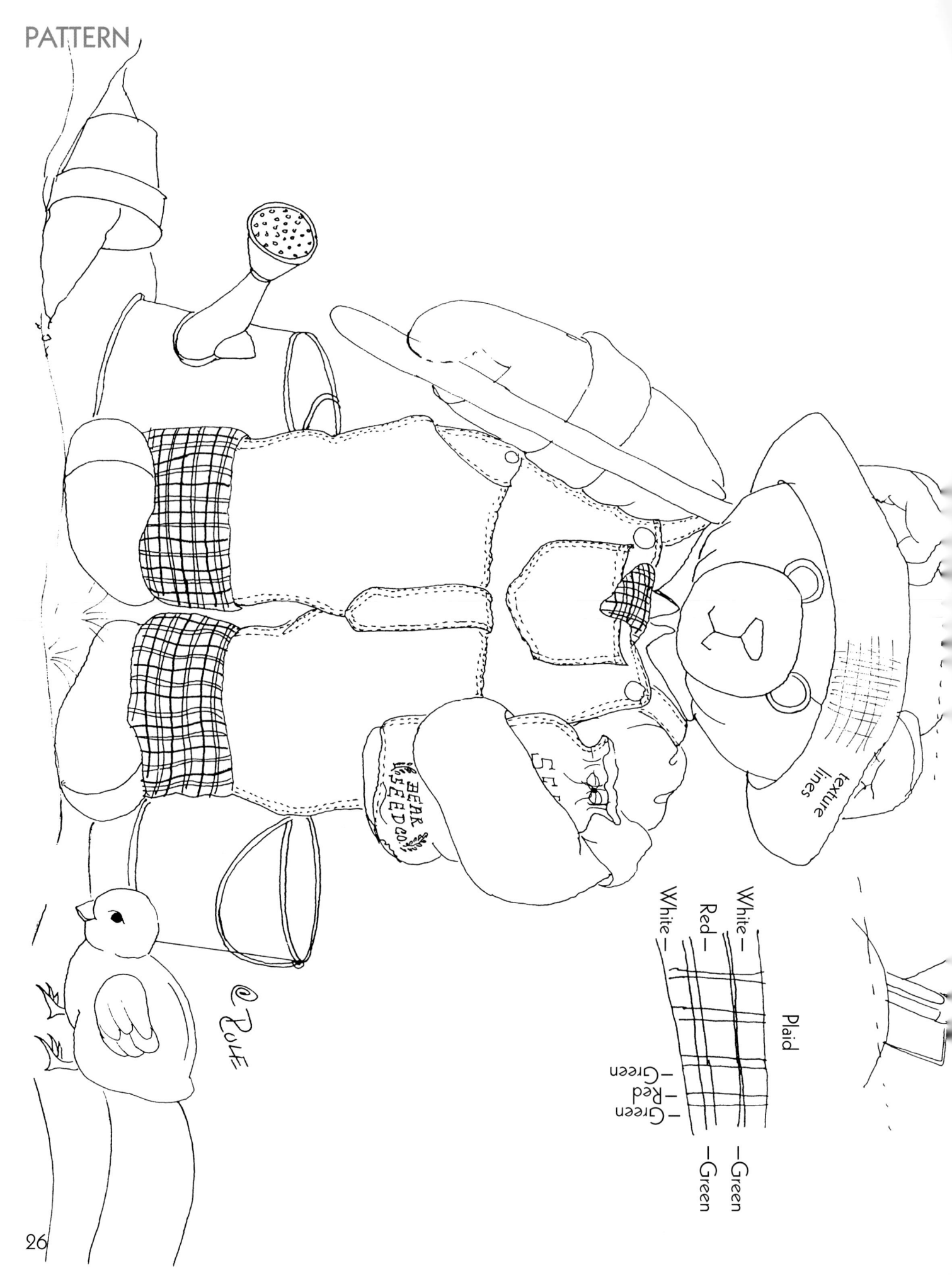

26

SHADE, HIGHLIGHT, AND ACCENT PLACEMENT DIAGRAM

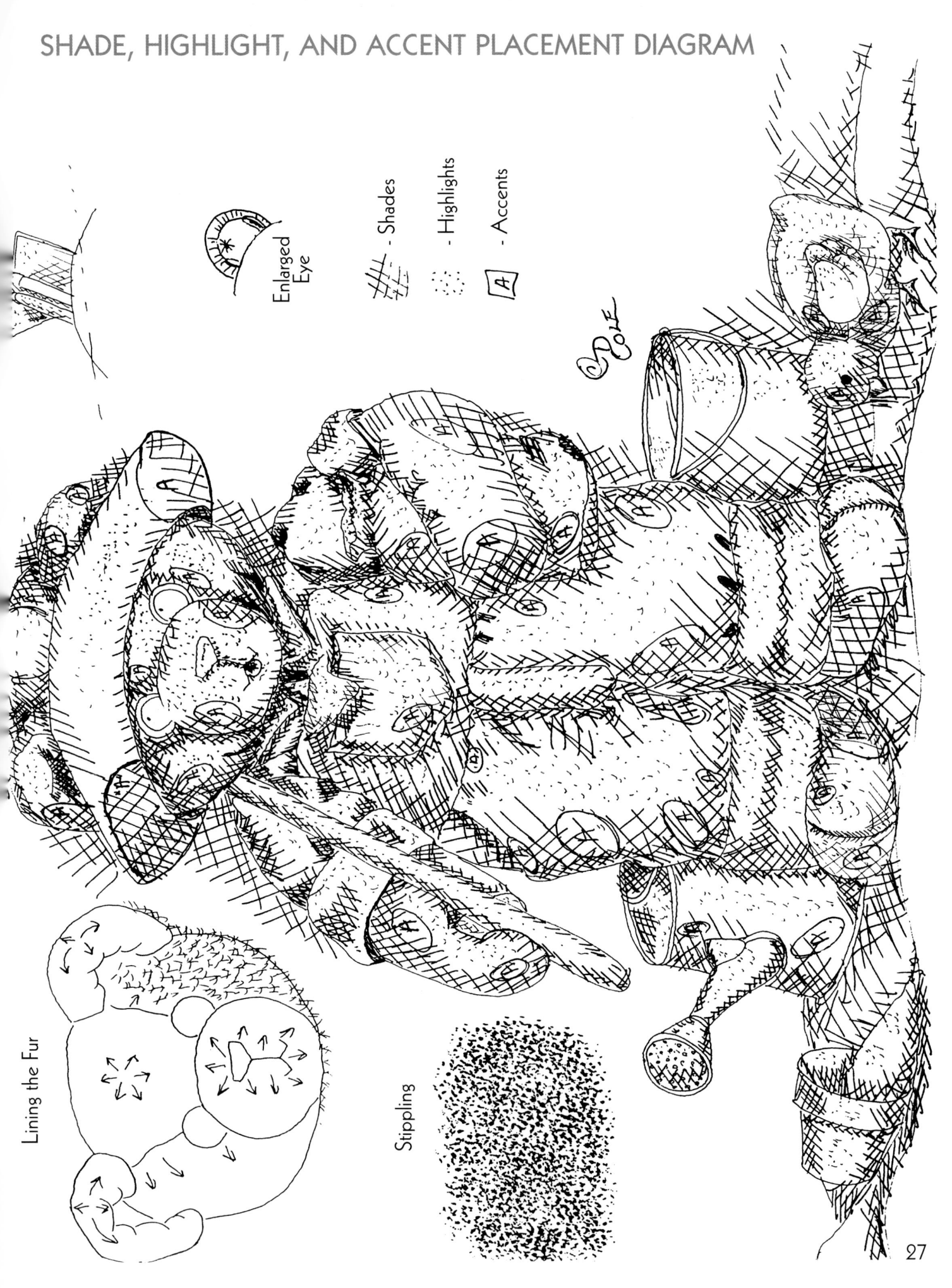

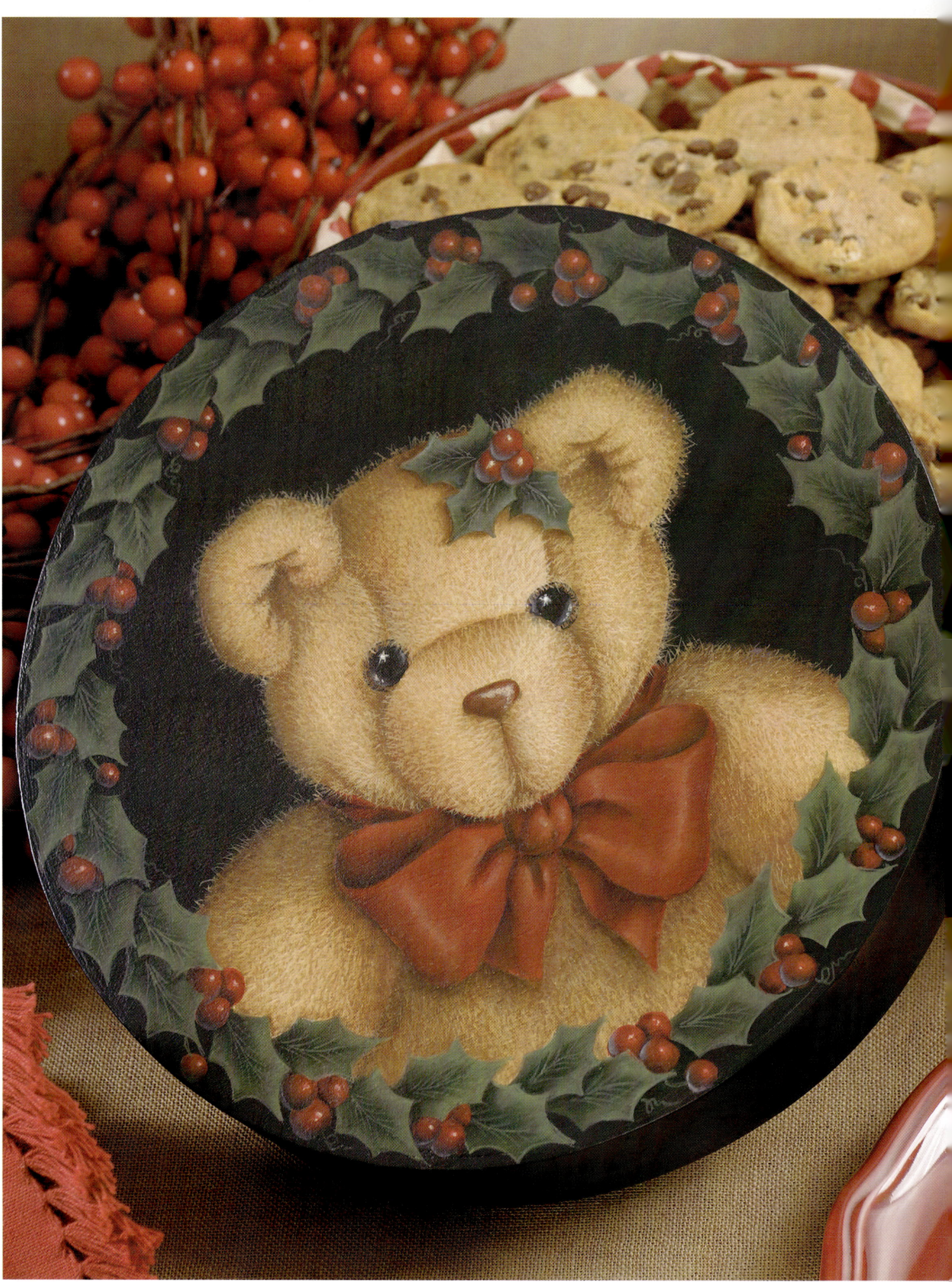

Holly

Palette
Delta Ceramcoat® Acrylics: Antique White, Black, Black Cherry, Black Green, Burnt Umber, Cape Cod Blue, Dark Burnt Umber, Dark Forest Green, Forest Green, Maple Sugar Tan, Maroon, Napthol Crimson, Old Parchment, Orange, Rain Grey, Raw Sienna, Spice Brown, Spice Tan, Tangerine, White

Surface
4 3/8"h x 9" dia. Round Wooden Box

Additional Supplies
Foam brush
Plastic wrap

Wood Preparation and Basecoating

Read the General Instructions, pages 89-92, before you begin to paint. Prepare the surface as stated in "Wood Preparation," page 89. Trace the design, page 33, onto tracing paper, then transfer the bear outline only onto the center of the lid. Basecoat the bear with Spice Tan. Basecoat the background with Black. Transfer all remaining pattern lines. The holly leaves are basecoated with Forest Green. Basecoat the berries and bow with Maroon. Line the details of the bear with Spice Brown, then basecoat the nose and irises with Spice Brown and the pupils with Black.

Painting Directions

Refer to the photos, pages 28 and 31-32, and the paint diagrams, pages 34-35, as you paint.

Bear

Dry brush the highlights on the bear with Maple Sugar Tan using a Cole Dry Brush, varying the size according to the area being painted. Float to shade the bear with Raw Sienna, walking out the float where necessary. Float the second shades with Spice Brown. Please note that each value change covers a smaller area than the previous one.

Stippling

The stippling colors are, from dark to light, Spice Tan, Maple Sugar Tan + Spice Tan (1:1), Maple Sugar Tan, and Maple Sugar Tan + Old Parchment (1:1). Once the stippling is completed, apply a wash of Raw Sienna all over the fur.

Fur Texture

Using a #0 liner brush and thinned paint, add small short hairs to the fur with the same colors that were used for the stippling. Just as in stippling, the lines should be one value lighter than the area being worked.

Glazing the Fur

Glaze the dark areas of the bear again, if they were lost, with Spice Brown. Now glaze Burnt Umber only in the darkest areas of the bear. If necessary, glaze Dark Burnt Umber in the darkest areas. Glaze Maroon accents.

Eyes

Line the perimeter of the irises with Black. Pull short Black lines across the irises. Float Rain Grey on both edges of the pupils. Add star shaped lines with Antique White in the upper left corners of the pupils. Place the final glints on with dots of White.

Nose

Shade the nose with Burnt Umber. Highlight the nose with Spice Tan, reinforcing the highlight with Maple Sugar Tan. Wash over the entire nose with Maroon. Add the final glint with Antique White.

Ribbon

Dry brush the first highlights with Napthol Crimson + Orange (2:1), using a Cole Dry Brush. Reinforce with a float of the same color. Some areas will need to be flip floated. Float the first shades with Black Cherry + Black (5:1), walking out where necessary. Remember to repeat this until a smooth coverage is achieved. Continue layering the second highlights with Orange, in the same manner as the first, covering a smaller area. Add the second shades with Black Cherry + Black (3:1) in the same manner as the first. This will cover a smaller area, also. The third highlights are Tangerine. Flip float only the brightest areas of the ribbon.

Berries

Use the same shade and highlight colors that were used on the ribbon and paint as follows. Dry brush the first highlights, keeping them in the upper right hand corners of the berries. Reinforce with small circular floats of Tangerine. The final glints are dots of Maple Sugar Tan, softened by blotting with your finger tip. Float to shade using a #6 flat brush. The first shades go around the entire perimeter of each berry. The second shades cover only the back halves of the berries. Apply the reflective lights by adding a narrow floats of Cape Cod Blue on the back edges of the berries.

Leaves

Float the first shades with Dark Forest Green + Black Green (3:1). Float to highlight with Forest Green + Antique White (2:1), repeating this until a smooth and even coverage is achieved. Reinforce shades with Black Green. Add vein lines using the highlight color.

Finishing

Sand and seal the bottom of the box, then basecoat it, inside and out, with Maroon. Create a glaze by using the Faux Glaze Base mixed with Black, following the directions on the back of the bottle. Using a foam brush, apply the Black glaze to the sides of the box. To create the "alligator" texture, place a sheet of plastic wrap all the way around the box. Press the wrap onto the sides, gently crinkling it. Lift the wrap off the sides so that the texture is not smeared. If the red basecoat does not show through or there is not enough texture showing, simply repeat the plastic wrap step. Repeat this step on the bottom and the insides of the box. Varnish as stated in "Varnishing," page 89.

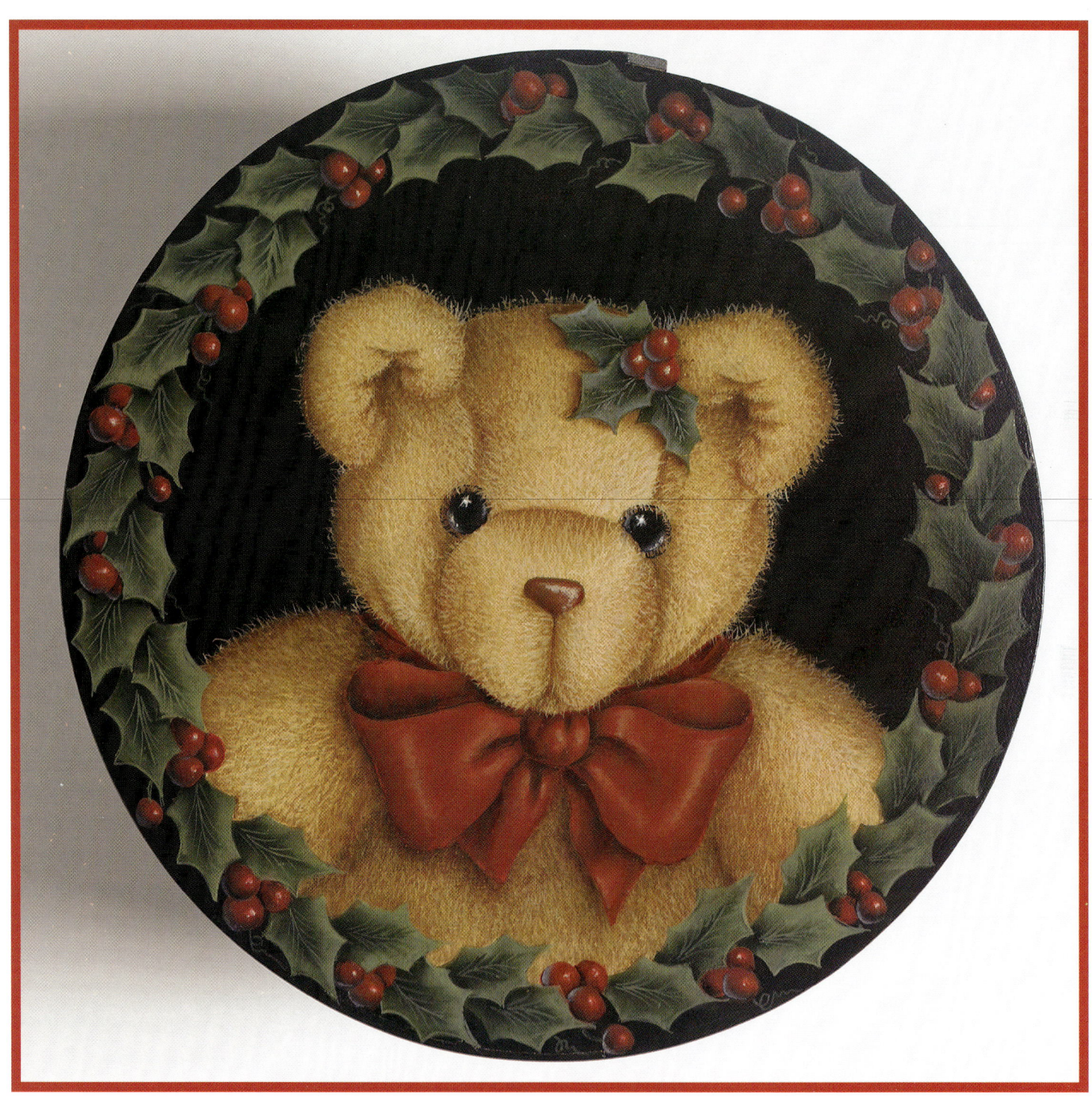

PATTERN

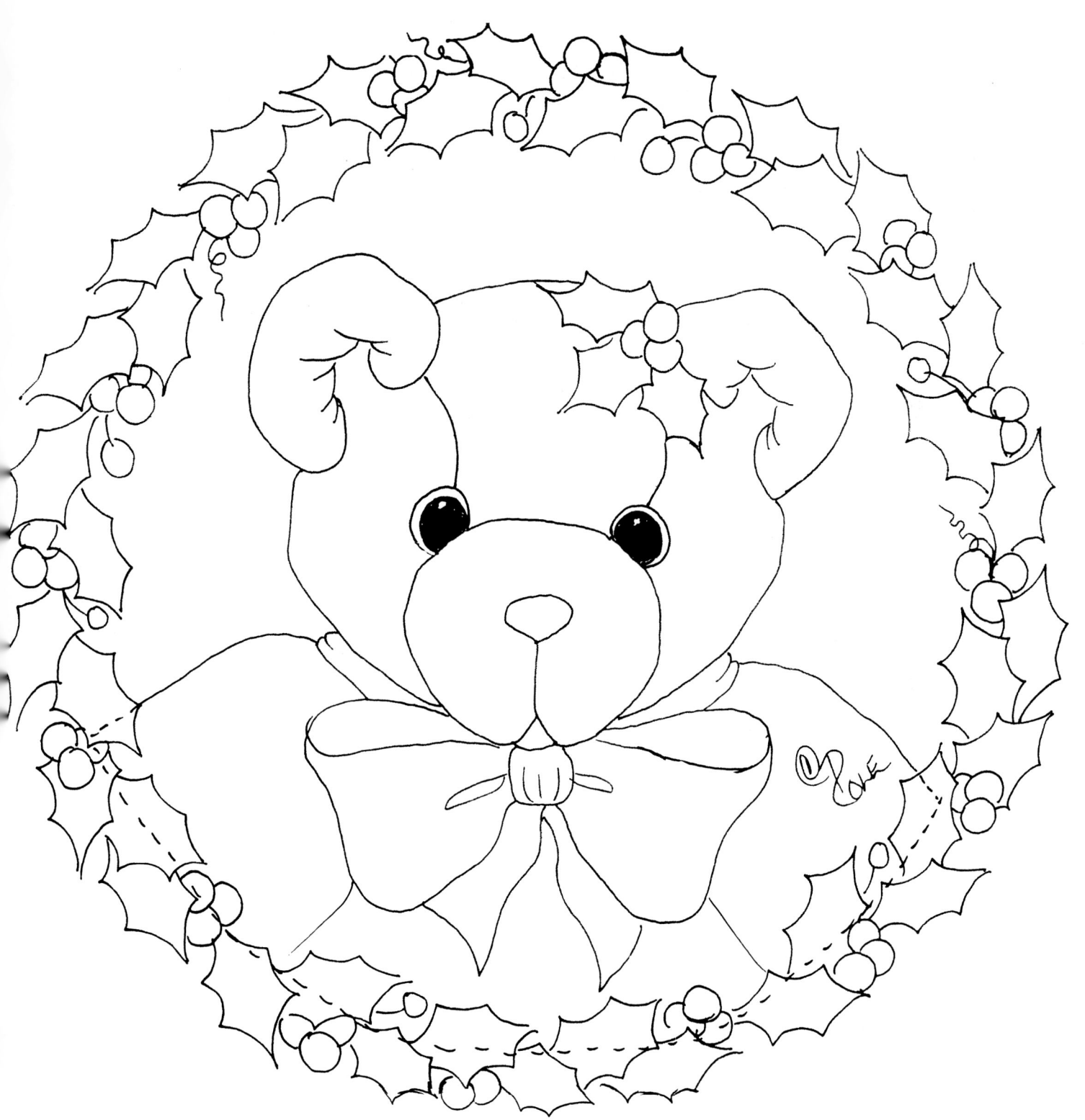

33

SHADE PLACEMENT DIAGRAM

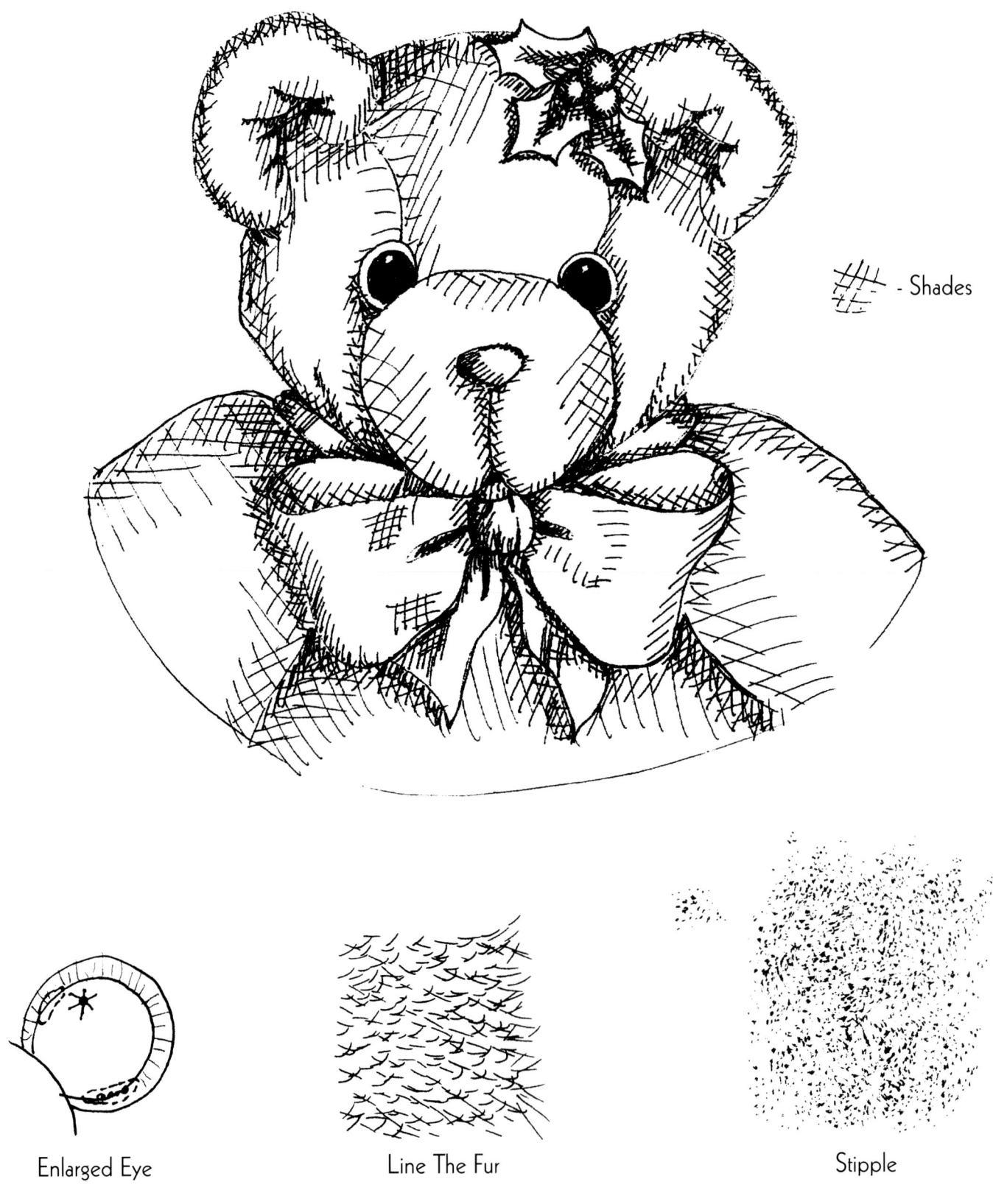

Enlarged Eye

Line The Fur

Stipple

HIGHLIGHT AND ACCENT PLACEMENT DIAGRAM

 - Highlights

 - Accents

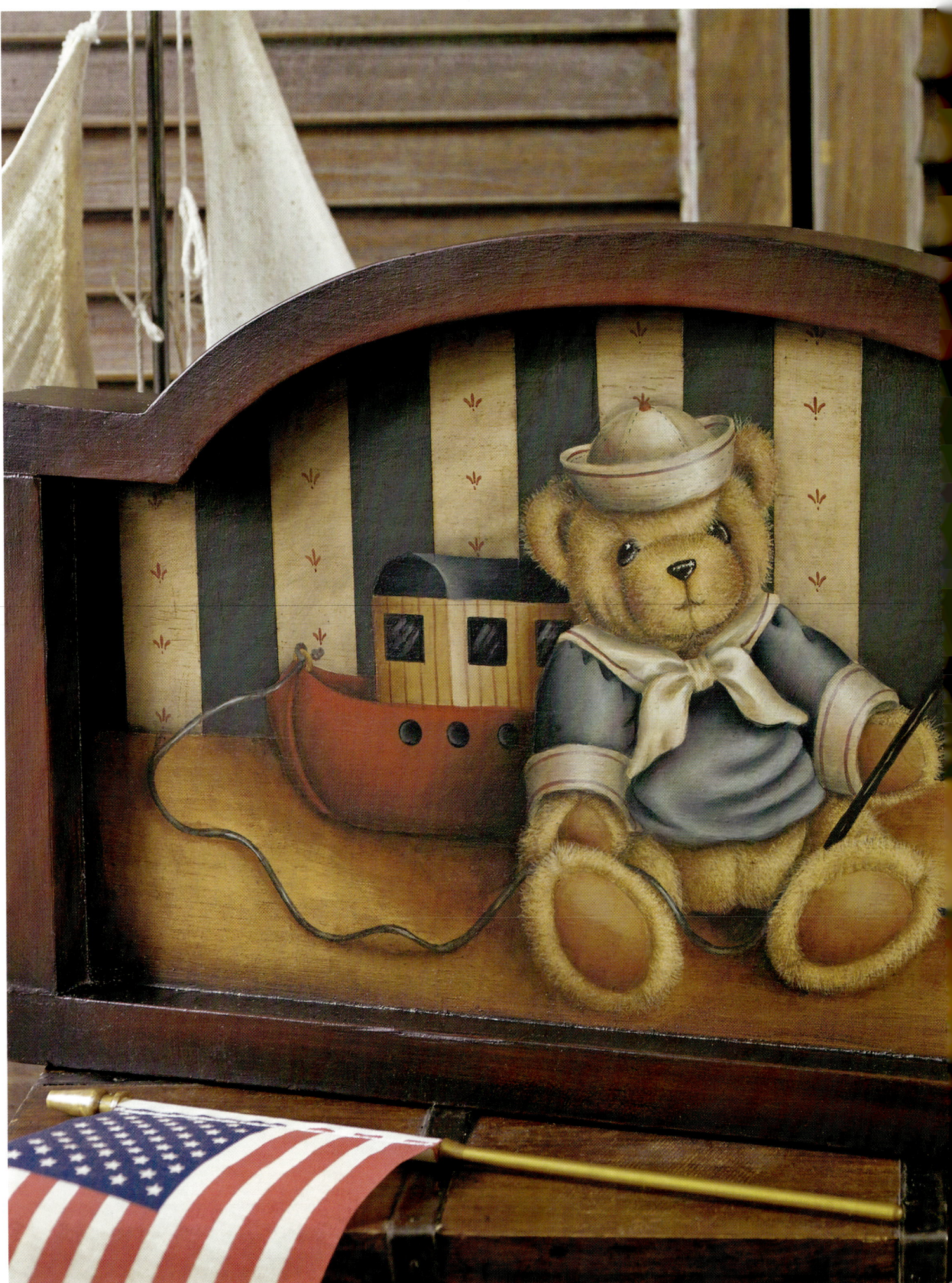

Davy

Palette
Delta Ceramcoat® Acrylics: Adriatic Blue, Antique White, Black, Burnt Umber, Cadet Grey, Candy Bar Brown, Cape Cod Blue, Dark Burnt Umber, Dark Night Blue, Dolphin Grey, Hippo Grey, Maple Sugar Tan, Old Parchment, Orange, Payne's Grey, Raw Sienna, Sandstone, Spice Brown, Spice Tan, Tide Pool Blue, Tomato Spice, White

Surface
9 3/4"x 17 1/8" Self-framed Wooden Plaque

Other Supplies
1"w painter's masking tape

Wood Preparation and Basecoating

Read the General Instructions, pages 89-92, before you begin to paint. Prepare the surface as stated in "Wood Preparation," page 89. Basecoat the inside of the plaque with Spice Tan. The outside of the plaque is basecoated with Tomato Spice. Trace the design, pages 44-45, onto tracing paper, then transfer the basic design onto the plaque. Tape off underneath the center line of the design. Also, tape off every other stripe in the background. Paint the dark stripes with Dark Night Blue + Adriatic Blue (1:1). When completely dry, lift off the tape on the stripes, then tape over the blue stripes and paint the light stripes with Sandstone. Remove all the tape and apply tape above the center line. Apply a light wash of Raw Sienna over the foreground. The bear's fur, the house of the tug boat, the ball on the top of the

flagpole, and the ring the rope ties around all remain Spice Tan. Basecoat the hat, cuffs, collar, entire flag, and the top of the flagpole with Sandstone. Basecoat the shirt and cord with Adriatic Blue. The tugboat roof is basecoated with Dark Night Blue. The bottom of the tugboat is basecoated with Tomato Spice. Transfer all remaining pattern lines. Basecoat the windows, portholes, and knob at the end of the cord with Payne's Grey. The stripes on the house, cord, flag, hat, cuffs, and collar, along with the ball on the top of the hat, are basecoated with Tomato Spice. Basecoat the blue square on the flag with Dark Night Blue. The eyes, nose, and remainder of the flagpole are basecoated with Black. At this point, add the lines on the bear with thinned Spice Brown using a #0 liner. Also, add the details to the light stripes in the background with comma strokes of Tomato Spice.

Painting Directions

Refer to the photos, pages 36-37 and 41-43, and the paint diagrams, pages 40 and 46-47, as you paint.

Background

Dry brush first, then float to reinforce the background area using Hippo Grey in the light areas and Black in the blue areas.

Foreground

Dry brush first, then float to reinforce, using Spice Brown, Burnt Umber, and Dark Burnt Umber. Cover a smaller area with each value change. Glaze accents with Candy Bar Brown and Tomato Spice.

Tugboat

Tugboat Roof

Float the first shades with Payne's Grey and first highlights with Adriatic Blue, walking them out. Float the second shades with Black and second highlights with Cape Cod Blue + Spice Tan (3:1), covering a smaller area than the first.

Tugboat House

Float and walk out the first shades with Spice Brown and highlights with Maple Sugar Tan. Add the second shades with Burnt Umber and the second highlights with Old Parchment, covering a smaller area than the first colors. Apply Tomato Spice lines in the light areas and Candy Bar Brown lines in the darker areas. Reinforce the shades and highlights with another float of the second colors. Float Dark Burnt Umber in the darkest areas next to the bear.

Tugboat Base

Float and walk out the first shades with Candy Bar Brown. Float on both sides of the front beam, leaving the basecoat color showing. Dry brush the first highlights with Tomato Spice + Orange (1:1) in the center areas and float the rest. Apply the second shades with Candy Bar Brown + Dark Night Blue (3:1) and highlights with Orange in the same manner as the first, covering a smaller area. Transfer the port holes and the house windows onto the tugboat base at this time. Basecoat these with Payne's Grey. Highlight with Adriatic Blue. Reinforce the highlights with Cape Cod Blue + Spice Tan (3:1), if necessary.

Ring in Tugboat
Use a ¼" flat brush to float Spice Brown to shade the ring and Maple Sugar Tan to highlight the ring. If this is too hard to float, you may line them in. Using your liner, add a small glint of Old Parchment as the final highlight.

Cord
Add Tomato Spice lines in a "C" shape to add pattern to the entire cord. Using a ¼" flat brush, float the left side of the cord with Dark Night Blue. Using the same brush, flip float the cord with Cape Cod Blue + Spice Tan (3:1) highlights, keeping these in the center of the cord. Reinforce the highlights with Tide Pool Blue.

Bear
Line the bear's features with Spice Brown. Float the first shades with Raw Sienna, walking them out where necessary. Float the second shades with Spice Brown. Dry brush the highlights with Maple Sugar Tan. Wash the bear with a very light wash of Raw Sienna.

Stippling
The stippling colors are, from dark to light, Spice Tan, Spice Tan + Maple Sugar Tan (1:1), Maple Sugar Tan, and Maple Sugar Tan + Old Parchment (1:1). After stippling, reinforce any shades and highlights to the paws, if necessary. Wash the bear again with a transparent wash of Raw Sienna.

Eyes and Nose
Float the highlights on the eyes with Hippo Grey. Use the same color to float on the nose. Use Cadet Grey to tap a few dots on top of these floats. Using Cadet Grey, line a star shape in the upper left corners of the eyes. Place final glints of White in the center of the stars.

Fur Texture
Line the fur using, from dark to light, Spice Tan + Maple Sugar Tan (1:1), Maple Sugar Tan, Maple Sugar Tan + Old Parchment (1:1), and Old Parchment.

Glazing the Fur
Glaze Burnt Umber in the darkest areas on the bear using a very transparent color. Reinforce the darkest of dark areas with a glaze of Dark Burnt Umber. Use this very sparingly. After glazing, wash the bear's paws and glaze in Tomato Spice accents.

Shirt
Dry brush the first highlights with Cape Cod Blue + Spice Tan (3:1). The first shades are Dark Night Blue + Adriatic Blue (1:1). Float these shades on the sleeves, on the left side of the mid-section, and under the collar. Dry brush the remaining areas. Add the second shades with Dark Night Blue and highlights with Dolphin Grey in the same manner. Glaze Payne's Grey in the darkest areas. Glaze Tomato Spice + Candy Bar Brown (1:1) accents.

Hat, Collar, and Cuffs
Float and flip float the first highlights with Antique White + Sandstone (1:1). Fill in the little dart areas with Sandstone + Hippo Grey (3:1). Use the same colors to float the first shades, walking them out where necessary. Apply the second shades with Sandstone + Hippo Grey (2:1) and highlights with Antique White in the same manner as the first, covering a smaller area. Add the red lines using Orange in the light areas, Tomato Spice in the middle value areas, and Candy Bar Brown in the dark areas. Add the last shades of Hippo Grey and highlights of White in the darkest and brightest areas only. Work the Hippo Grey on the palette paper until a soft float is achieved. Add the stitching with Dark Night Blue. Glaze Tomato Spice accents.

Flag

Red Stripes
Use the colors from the tugboat base.

White Stripes and Upper Flagpole
Use the colors from the hat. The stripes must be isolated. Flip float the shades and highlights using the same colors as the boat base. Touch up the white stripes, if necessary. Flip float the shades and highlights to these, also. Float to shade the upper flagpole and flip float the highlights.

Blue Area
Use the same colors as the tugboat roof. Flip float and float the first shades and highlights. Apply Sandstone dots to the area. Apply the second shades and highlights in the same manner as the first, covering a smaller area.

Flagpole
Flip float Hippo Grey to highlight the center of the pole. Reinforce with a line of Hippo Grey + Sandstone (1:1).

Flagpole Knob
Use the same colors as the tugboat house. Dry brush the highlights. Float to shade the left side.

Finishing
Varnish as stated in "Varnishing," page 89.

Enlarged Cord

Stippling

Lining the Fur

41

43

PATTERN

44

PATTERN

45

SHADE PLACEMENT DIAGRAM

⋕ - Shades

46

HIGHLIGHT AND ACCENT PLACEMENT DIAGRAM

- Highlights

[A] - Accents

47

Rosie

Palette
Delta Ceramcoat® Acrylics: Antique White, Black, Custard, Drizzle Grey, Eucalyptus, Forest Green, Golden Brown, Hydrangea Pink, Light Ivory, Napthol Red Light, Purple, Purple Dusk, Quaker Grey, Rain Grey, Storm Grey, Straw, Sunbright Yellow

Surface
$6^7/_8$" x 8" Hexagonal Wooden Box

Wood Preparation and Basecoating
Read the General Instructions, pages 89-92, before you begin to paint. Prepare the surface as stated in "Wood Preparation," page 89. Basecoat the top of the lid with Quaker Grey. Sand lightly removing any brush strokes. Trace the design, pages 52-53, onto tracing paper, then transfer all of the design and border onto the box lid. Use a ruler to keep the edges of the border straight. Basecoat the background behind the bear with Purple Dusk, the outside border and bottom of the box with Custard + Straw (1:1), and the dress with Straw. The bear and collar remain Quaker Grey. The pupils and nose are basecoated with Black.

Painting Directions
Refer to the photos, pages 49 and 51-52, and the paint diagrams, pages 52 and 54-55, as you paint.

Bear
Line the bear's facial features with thinned Rain Grey + Storm Grey (1:1) using your #00 liner brush. Dry brush the highlights with Drizzle Grey, using a Cole Dry Brush and varying the size according to the area being painted. Dry brush the second highlights with Drizzle Grey + Antique White (2:1), covering a smaller area.

Stippling
(This bear is completed using my two-step stippling method.)

First Stippling: The first stippling colors are, from dark to light, Drizzle Grey, Drizzle Grey + Light Ivory (3:1), and Light Ivory + Drizzle Grey (1:1). Using a Cole Scruffy Brush, begin adding texture by stippling very lightly. Vary the size of the brush according to the area being painted. Apply the color one value lighter than the area being worked. For example, in the dark areas use Drizzle Grey. In the lightest areas use Light Ivory + Drizzle Grey (1:1).

Second Stippling: Once the first stippling is completed, move up in value and stipple again. The second stippling colors are Drizzle Grey + Light Ivory (3:1), Light Ivory + Drizzle Grey (1:1) and Light Ivory. Stipple one value lighter than the area being painted, just as the first stippling. This will create a softer fur.

Glazing the Fur
Glaze the dark areas with Rain Grey. Glaze Storm Grey only in the darkest areas of the bear. Glaze Napthol Red Light as the accents.

Fur Texture
To line the fur, use a #00 liner brush and thinned paint. Add short criss-crossed hairs only to the outside edges of the bear with Quaker Grey. These lines should be approximately $1/_8$" long.

Eyes
Add a line of Purple Dusk to the outside edges of the pupils to indicate the irises. Float Quaker Grey as the reflective lights in the eyes. Add Drizzle Grey dots as glints on top of these floated areas. Use this color to form small star-shaped glints in the upper left hand corners of the pupils. Add Light Ivory as the final glints in the middle of the stars.

Nose
Dry brush to highlight with Purple Dusk + Black (3:1). Dry brush the second highlight of Purple Dusk. Add a final highlight of Purple Dusk + Light Ivory (1:1).

Dress
The dress is created with multiple layers of highlights. There are no floated shades. Dry brush the first highlights with Sunbright Yellow + Straw (2:1). Use Sunbright Yellow to add the second highlights. These are applied the same manner as the first, covering a smaller area. The third highlights are applied with Custard, covering a very small area. Add small "roses" with dots of Purple Dusk, then add smaller dots of Hydrangea Pink as the highlights. Pull small leaves of Eucalyptus. When dry, add another application of the Custard highlight onto the dress. Glaze the dark areas of the dress with Golden Brown. Glaze the darkest areas of the dress with Purple Dusk.

Collar
Float to highlight using the same colors as the bear. If necessary, dry brush to cover the proper width if you can not walk out a float. Glaze the first shades with Purple Dusk. Add a second glaze of Purple + Storm Grey (1:1). Basecoat the two roses with Straw and the leaves with Eucalyptus. Outline roses and leaves with thin lines of Purple Dusk. Add loose strokes of Hydrangea Pink as the highlights. The lace on the edges of the collar is done with Light Ivory. The stitches are lines of Purple Dusk.

Border
Outline the vine and leaves very lightly with Forest Green. Fill in the leaves with Eucalyptus. Add roses with dots of Purple Dusk with Hydrangea Pink swirls as the highlights. The roses in each corner of the box are completed just like those on the collar.

Remainder of the box
Basecoat the remainder of the box with Purple Dusk. Lightly sponge over this area with Custard + Straw (1:1). Add a Custard + Straw (1:1) $1/4$" border to the sides, right above where the two come together. Paint the details as stated in the border paragraph above, eliminating the yellow roses. The larger rose is placed in the center of the bottom sections of the box. Paint these in the same manner as the yellow roses on the border.

Finishing
Varnish as stated in "Varnishing," page 89.

HIGHLIGHT PLACEMENT DIAGRAM

Star Highlight

Eyes

Floated & Glints

PATTERN

Rose on Sides of Box

52

PATTERN

SHADE PLACEMENT DIAGRAM

- Shades

54

HIGHLIGHT AND ACCENT PLACEMENT DIAGRAM

- Highlights
- Accents

Pearl

Palette
Delta Ceramcoat® Acrylics: Adobe Red, Antique White, Black, Blue Haze, Blue Wisp, Bridgeport Grey, Burnt Umber, Cadet Grey, Coral, Dark Night Blue, Flesh Tan, Golden Brown, Gypsy Rose, Hippo Grey, Maple Sugar Tan, Mudstone, Old Parchment, Pink Angel, Queen Anne's Lace, Raw Sienna, Rose Petal Pink, Sandstone, Spice Brown, Spice Tan, Straw, White
Delta Gleams™: Metallic 14K Gold

Surface
6 3/8"w x 11 1/2"h Wooden Tea Box

Wood Preparation and Basecoating
Read the General Instructions, pages 89-92, before you begin to paint. Prepare the surface as stated in "Wood Preparation," page 89. Basecoat the entire box with Flesh Tan + Antique White (1:1). Using a sea sponge, lightly sponge the box with Cadet Grey, then with Metallic 14K Gold. Trace the design, page 60, onto tracing paper, then transfer the design, excluding the bear details, the net on the hat, the lace on the dress, the flowers on the tea cup and pot, and the necklace, onto the tea box. Basecoat the leaves, lettering, and table with Blue Wisp + Mudstone (2:1); the hat, dress, pink flowers on hat, and roses with Pink Angel + Flesh Tan (2:1); the ribbon with the leaf basecoat color + Antique White (1:1); the tablecloth with Flesh Tan + Antique White (1:1); the teapot and cup with Sandstone; the yellow flowers on the hat with Old Parchment + Maple Sugar Tan (1:1); and the bear with Maple Sugar Tan. Transfer the details onto the bear, then basecoat the irises with Spice Brown, the pupils with Black, and the nose with Gypsy Rose.

Painting Directions
Refer to the photos, pages 57 and 59, and the paint diagrams, page 61, as you paint.

Leaves, Lettering, and Table
Leaves
Float to shade with Blue Haze + Bridgeport Grey (2:1) and highlight with the basecoat color + Antique White (1:1). Reinforce the second shades with Blue Haze + Dark Night Blue (3:1) and the highlights with first highlight color + Antique White (1:1).

Lettering
Line and/or float to shade using the second color from the leaves.

Table
Using the same colors as on the leaves, float and walk out the first shades and highlights. Add the second shades and highlights, covering a smaller area. Glaze Dark Night Blue to the left and under the left arm.

Ribbon
Float and flip float the first shades with Blue Wisp + Mudstone (2:1) and the highlights with the basecoat color + Antique White (1:1). Add the second shades with Blue Haze + Bridgeport Grey (2:1) and the highlights with Antique White.

Hat, Dress, Pink Flowers on Hat, and Roses
Pink Flowers and Roses
Float to shade with Coral and highlight with Pink Angel + Queen Ann's Lace (1:1). Float the second shades with Gypsy Rose and the second highlights with Queen Anne's Lace. On the roses, reinforce the shades with a float of Adobe Red in the darkest areas.

Hat and Dress

Float the first shades using the same colors as the flowers and roses. The first highlights may be dry brushed or flip floated using the same colors as the flowers and roses. Reinforce the shades and highlights in the same manner as the first covering a smaller area. Reinforce the darkest areas only with floats of Adobe Red. Glaze over the darkest areas with Spice Brown. The areas on the hat need to be very dark, so reinforce these areas again with a glaze of Burnt Umber. (Please note that the bear should be completely finished before doing this next step.) Using white graphite, transfer the netting and lace onto the bear. Line the netting and the lace with Pink Angel + Flesh Tan (2:1) in the dark areas, Pink Angel + Rose Petal Pink (2:1) in the middle areas, and Rose Petal Pink in the light areas. Wash over the netting with Pink Angel + Flesh Tan (2:1). Wash over the lace with the same color in the dark areas and Pink Angel + Rose Petal Pink (2:1) in the middle areas. Add dots where the lines cross over using the color that is at least one value lighter than the area being painted. Dry brush highlights on the netting and in the middle area of the lace using Rose Petal Pink. I pulled some glazes of Gypsy Rose across the lace in the dark areas to form little ripples. Transfer the necklace onto the bear and basecoat with Sandstone. Shade with Mudstone and highlight with Antique White. Add a final dot of White as the last highlight.

Tablecloth

Float and flip float the shades with Flesh Tan + Spice Tan (4:1), reinforced with Flesh Tan + Spice Tan (2:1). If necessary, float Spice Tan in the darkest areas. Dry brush the highlights with the basecoat color + Antique White (1:1). Add a second highlight with Antique White. Using your liner brush, add the lace using the basecoat color in the dark areas and the first highlight color in the light areas. Glaze Gypsy Rose accents.

Teapot and Cup

Float the first shades with Sandstone + Mudstone (1:1). Reinforce with a second shade of Mudstone. Float and flip float the first highlights with Sandstone + Antique White (1:1). Reinforce the highlights with Antique White. Transfer on the roses and leaves. Basecoat, shade, and highlight in the same manner as the large roses. Add the third shades with Mudstone + Hippo Grey (1:1). Float to add the reflective light using the first shade color. Glaze on Raw Sienna as the accents. Line the gold rims with Golden Brown, then add the highlights by overlapping lines of Straw, Straw + Old Parchment (1:1), and Antique White. These lines get shorter with each application. Float the steam with Cadet Grey, highlighting it with small floats of Sandstone.

Yellow Flowers on Hat

Float the shades with Maple Sugar Tan + Straw (1:1), reinforced with Straw + Golden Brown (2:1). Float the highlights with Old Parchment reinforced with Antique White.

Bear

Line the features of the bear with Golden Brown. Float to shade the bear with Spice Tan, reinforced with Raw Sienna. Dry brush the highlights with Maple Sugar Tan + Old Parchment (1:1). Apply a very light wash of Golden Brown all over the bear.

Stippling the bear

The stippling colors from dark to light are, Spice Tan + Maple Sugar Tan (1:1), Maple Sugar Tan, Maple Sugar + Old Parchment (1:1), and Old Parchment. After stippling, wash the bear with a thin wash of Golden Brown.

Eyes and Nose

Touch up the eyes and nose, if necessary, with the basecoat colors. Line the outside of the irises with a very thin line of Black. Then go onto the irises and apply small lines all the way around the inside of the irises. Float to the left and to the right sides of the pupils with Bridgeport Grey, then add Cadet Grey dots to these floats. Use small lines of Cadet Grey to make a star like shape in the upper left corners of the pupils. Add dots of White in the center of the stars to make the final glints. Float to shade the nose with Spice Brown. Highlight with a float of Pink Angel. Add final glints with Antique White.

Fur Texture

Line the fur using, from dark to light, Maple Sugar Tan, Maple Sugar Tan + Old Parchment (1:1), Old Parchment, and Old Parchment + Antique White (1:1). After lining the fur, wash over the bear with a thin wash of Golden Brown.

Glazing the Fur

Glaze Spice Brown, using a very transparent color, in the darkest areas on the bear. Referring to the accent diagram, glaze Gypsy Rose accents onto the bear.

Finishing

Varnish as stated in "Varnishing," page 89.

PATTERN

Tea Time

60

SHADE PLACEMENT DIAGRAM

▦ - Shades

○ - Highlights
Ⓐ - Accents

HIGHLIGHT AND ACCENT PLACEMENT DIAGRAM

61

Sam

Palette
Delta Ceramcoat® Acrylics: Adriatic Blue, Antique White, Black, Burnt Umber, Candy Bar Brown, Dark Night Blue, Hammered Iron, Lichen Grey, Maple Sugar Tan, Mudstone, Old Parchment, Raw Sienna, Sandstone, Spice Brown, Spice Tan, Tomato Spice

Surface
$20^{1}/_{2}$" x $12^{1}/_{2}$" x 4" Americana Carry-All Basket

Wood Preparation and Basecoating
Read the General Instructions, pages 89-92, before you begin to paint. Remove the lid from the basket to make painting easier. Sand, then seal the lid on both sides, including the metal brackets. Sand again lightly, making sure the lid is smooth, repeat these steps, if necessary. Basecoat the entire lid with Candy Bar Brown. Apply at least two coats, sanding in between coats very lightly to remove any ridges. Each lid size may vary a little, so some adjustments may be necessary in applying the design. Measure in $2^{1}/_{8}$" from the bottom and top of the basket and $2^{1}/_{8}$" from the sides. Using a see-through ruler, draw the bottom line first. Be sure to keep it level with the bottom of the basket. Use this line as the reference line to keep the rest of the lines level or square. Now draw the side and top lines; the main design will go inside these lines. The squares created by overlapping the lines in the outer corners of the basket are basecoated with Dark Night Blue + Adriatic Blue (1:1). Using the $^{5}/_{8}$" Scotch Magic Tape, paint the stripes on the sides, bottom, and top, using Spice Tan + Raw Sienna (1:1). Wash the bottom of the basket with Raw Sienna. This may need to be repeated twice. Wash every other horizontal splint with Tomato Spice. Repeat if necessary. Trace the design, pages 70-71, onto tracing paper. Make sure the design is traced using the reference line to keep everything level. Match the reference line to the bottom line on the basket lid as you transfer the design. It is very important that the design is level. Basecoat the bear, rear crock, drum sticks, and drumhead with Spice Tan; the large crock, drum center, right side of bear's vest and left side of bow with Mudstone; the drum rims and large stripe on rear crock with Adriatic Blue + Spice Tan (5:1); the left side of bear's vest and right side of bow with Dark Night Blue + Adriatic Blue + Spice Tan (5:5:1); the bear's irises Spice Brown; and the pupils and nose with Black. The rest of the details will be added after the first and second stages are completed.

Painting Directions
Refer to the photos, pages 63 and 66-69, and the paint diagrams, pages 72-73, as you paint.

Large Crock and Drum Center
Dry brush the highlights with Lichen Grey + Sandstone (4:1). Reinforce the highlights with floats of the same color. Float and walk out the first shades with Mudstone + Hammered Iron (3:2), dampening the area with water first to help move the paint. Add the second shades with Hammered Iron + Mudstone (2:1) and the second highlights with Lichen Grey +

63

Sandstone (2:1) in the same manner as the first, covering a smaller area. Transfer the details onto the crock and drum. Outline the details on the drum with Adriatic Blue, using a #0 liner and thinned paint. Wash the eagle with Raw Sienna, the stripes with Tomato Spice, and all the blue areas with Adriatic Blue. Basecoat the blue details on the crock with Adriatic Blue + Mudstone (1:1). Basecoat the red stripes on the crock with Tomato Spice + Mudstone (2:1). Add the third shades to the crock with Hammered Iron and the highlights with Sandstone in the same manner as the others, covering even a smaller area. These will go right over the details to help set the details onto the drum and crock. Glaze the darkest areas with Hammered Iron + Black (1:1). Glaze accents with Raw Sienna. Add the rust to the drum by patting in Raw Sienna with a #3 round brush. Now pat in Spice Brown covering a smaller area and Burnt Umber in the smallest area. Flip float a final glint with Sandstone + Antique White (1:1). Add the reflective light by dry brushing and/or floating Adriatic Blue + Spice Tan (2:1), reinforced with Adriatic Blue + Maple Sugar Tan (2:1), then only in the brightest areas of the reflective light, add Adriatic Blue + Maple Sugar Tan (1:1).

Rear Crock, Drum Sticks, and Drumhead

The first highlights are dry brushed with Maple Sugar Tan + Spice Tan (3:1), adjusting the size of the brush for the area. Reinforce with floats of the same color. Float the first shades with Raw Sienna, walking them out where necessary. Also, on the crock, dampen the area first, then walk out the float. Apply the second shades with Raw Sienna and the highlights with Maple Sugar Tan + Old Parchment (1:1) in the same manner as the first, covering a smaller area. Dampen the crock, then, using an Cole Scruffy brush, stipple the texture onto the crock with Dark Night Blue + Black (3:1), Dark Night Blue, and Dark Night Blue + Adriatic Blue (1:1). Apply the dark color in the darkest areas, the middle color in the middle areas, and the light color in the lightest areas. Soften with a damp flat brush or mop brush. Add the thin stripes on the crock using the same blue colors as the stippling. Glaze the third shades with Burnt Umber in the darkest areas. This is repeated multiple times to add the cast shadow from the large crock onto this crock. Glaze Tomato Spice accents on the drumhead. Add reflective lights in the same manner as the large crock.

Drum Rims and Large Stripe on Rear Crock

Dampen the area to be highlighted and flip float the first highlights with Adriatic Blue + Maple Sugar Tan (3:2), walking out where necessary. Float the first shades with Dark Night Blue + Adriatic Blue + Spice Tan (5:5:1), walking out where necessary. Apply the second shades with Dark Night Blue and highlights with Maple Sugar Tan + Adriatic Blue (1:1) in the same manner as the first, covering a smaller area. Glaze the third shades with Dark Night Blue + Black (2:1) in the darkest areas. On the drum rims, add a final glint of Sandstone by softly flip floating. Add the reflective lights referring to the Large Crock directions.

Bear

Line the bear's features with Spice Brown. Float the first shades with Raw Sienna, walking them out where necessary. Reinforce these shades with Spice Brown. Dry brush the highlights with Maple Sugar Tan.

Stippling the Bear

The stippling colors are, from dark to light, Spice Tan, Spice Tan + Maple Sugar Tan (1:1), Maple Sugar Tan, and Maple Sugar Tan + Old Parchment (1:1). After stippling, reinforce any shades and highlights to the paws, if necessary. Wash the bear with a transparent wash of Raw Sienna.

Eyes and Nose
Touch up the eyes and nose, if necessary, with the basecoat colors. Refer to the enlarged eye diagram and line the outside of the irises with Black. Add little Black lines around the irises. Float the highlights on the eyes with Mudstone + Lichen Grey (2:1). Use the same color to float a highlight on the nose. Use Lichen Grey to tap a few dots on top of these floats. Using Lichen Grey, line a star shape in the upper left corners of the eyes. Place final glints of Antique White in the center of the stars. Reinforce the highlight on the nose with Lichen Grey, also. Tap a final glint of Antique White in the lightest area.

Fur Texture
Line the fur using the same colors that were used for stippling.

Glazing the Fur
Glaze Burnt Umber, using a very transparent color, in the darkest areas on the bear. Reinforce the darkest areas with a glaze of Dark Night Blue. Use this very sparingly. After glazing, wash the bear's paws and glaze in accents using Tomato Spice.

Vest and Bow Tie
White Areas
Use the same shade and highlight colors as the Large Crock.

Blue Areas
Dry brush the highlights on the vest with Adriatic Blue + Spice Tan (5:1). Float the bow tie using the same colors. Add the second highlights in the same manner with Adriatic Blue + Maple Sugar Tan (3:2). Dry brush first, then float the shades on the vest with Dark Night Blue. Float the shades on the bow tie. Add the second shades in the same manner as the first with Dark Night Blue + Black (2:1). Transfer the details onto the vest and bow tie. Wash Tomato Spice stripes on the white sides and add Mudstone stars to the left sides. The stars are just dots with little lines pulled off of the dots. Add the second shades again, then glaze Black into the darkest areas. Transfer the buttons onto the vest. Basecoat the buttons with Dark Night Blue. Add two Mudstone dots to the center of the buttons.

Background and Foreground
Dry brush the highlights with Tomato Spice. Reinforce highlights with another dry brush of Tomato Spice + Spice Tan (3:1). Reinforce again in the foreground with a float of the same color. Dry brush the shadows with Candy Bar Brown + Black, (4:1), then glaze with Black to reinforce.

Finishing
Antique the basket bottom and lid with floats of Black. Use as large a brush as possible. Float the outside perimeter on the lid, keeping it very soft. Float the top of the basket on the top splint. To age the basket, apply a very light wash of Black all over the bottom of the basket. Varnish as stated in "Varnishing," page 89. Do not varnish the bottom of the basket.

69

PATTERN

↑ Reference Line

70

PATTERN

↑ Reference Line

71

SHADE PLACEMENT DIAGRAM

- Shading & Shadows
- Lining Fur
- Stippling the Fur

72

HIGHLIGHT AND ACCENT PLACEMENT DIAGRAM

- Highlights
- Reflective Light
- Accents

73

Carlos

Palette
Delta Ceramcoat® Acrylics: Antique White, Black, Black Green, Burnt Umber, Chrome Green Light, Cinnamon, Custard, Dark Forest Green, Maple Sugar Tan, Old Parchment, Pigskin, Pine Green, Quaker Grey, Rain Grey, Raw Sienna, Spice Brown, Spice Tan, Straw, Tomato Spice, White

Surface
11^3/$_8$" x 13^3/$_8$" Wooden Frame with Insert

Wood Preparation and Basecoating
Read the General Instructions, pages 89-92, before you begin to paint. Prepare the surface as stated in "Wood Preparation," page 89. Basecoat the entire frame with Raw Sienna. Use a ruler to line off the four corners and basecoat with Pine Green + Cinnamon (3:1). Splatter the entire frame with this green color. Trace the frame corner pattern, page 79, onto tracing paper, then transfer the diamond shape onto corners of frame. Basecoat with Cinnamon + Tomato Spice + Spice Tan (3:2:2). Transfer the rest of the detail on the diamonds. Paint the dark lines with Black Green, the yellow lines with Pigskin, and the green areas with Pine Green + Cinnamon (3:1). Basecoat the insert with Spice Tan. Trace the bear design, page 79, onto tracing paper, then transfer on the design excluding the small details. Basecoat the background with Pine Green + Cinnamon (3:1); the hat and top of the guitar with Raw Sienna + Straw (4:1); the bottom of the guitar with Spice Brown; the poncho with Cinnamon + Tomato Spice + Spice Tan (3:2:2), the irises with Spice Brown; the pupils with Black; and the nose with Spice Brown. The bear will remain Spice Tan. The remainder of the design will be added at a later time.

Painting Directions
Refer to the photos, pages 75 and 77-78, and the paint diagrams, pages 80-81, as you paint.

Background
The shadows are floated with Black Green, reinforced with Black in a smaller area. The highlights are dry brushed in the back and floated in the front using Pine Green, Dark Forest Green, and finally Chrome Green Light.

Bear
Dry brush the highlights on the bear with Maple Sugar Tan using a Cole Dry Brush, varying the size according to the area being painted. Float to shade the bear with Raw Sienna, walking out the float where necessary. Reinforce with a second shade of Spice Brown. Please note that each value change covers a smaller area than the previous one. The last shade of Burnt Umber is placed only in the darkest areas on the bear.

Stippling
The stippling colors are, from dark to light, Spice Tan, Maple Sugar Tan + Spice Tan (1:1), Maple Sugar Tan, and Maple Sugar Tan + Old Parchment (1:1). After the stippling is completed, wash the entire fur with a wash of Raw Sienna.

Fur Texture
Using a #0 liner brush and thinned paint, add small short hairs to the fur. Just as in stippling, the lines should be one value lighter than the area being worked. Use the same colors that were used for stippling.

Glazing the Fur
Glaze the dark areas of the bear again if they were lost with Burnt Umber. Now glaze Black Green only in the darkest areas of the bear. Glaze Tomato Spice accents.

Eyes
Line the perimeter of the irises with Black. Pull short Black lines across the irises. Float Rain Grey on both edges of the pupils. Tap a few Quaker Grey glints in the center of these floated areas. Add star-shaped Antique White lines in the upper left corners of the pupils. Add the final glints with dots of White.

Nose
Shade the nose with Burnt Umber. Highlight the nose with Spice Tan, reinforcing with Maple Sugar Tan. Add the final glints with Antique White.

Poncho
Dry brush the first highlights with Tomato Spice + Spice Tan (1:1). Float the first shades with Cinnamon, walking them out where necessary. Add the second shades with Cinnamon + Black Green (5:1) and the second highlights with Tomato Spice + Pigskin + Spice Tan (1:1:1) in the same manner as the first, covering a smaller area. Transfer on the decorative stripes. The green areas are washes of Pine Green + Cinnamon (3:1). The dark lines are Black Green. The golden lines are Pigskin. The red areas are the poncho color that remains. Add the last shade with Cinnamon + Black Green (3:1) and the last highlights with Pigskin only in the darkest and lightest areas. Glaze Black Green in the darkest areas. Float the reflective light using the basecoat color.

Hat
Dry brush the first highlights with Straw. Float the same color to reinforce this area. Float the first shades with Spice Brown, walking out the float where necessary. Add the remainder of the shades with Burnt Umber and highlights with Straw + Custard (2:1) in the same manner as the first, covering a smaller area with each step. Add the hat band in the same manner as the design on the poncho. Glaze Black Green in the darkest areas on the hat. Glaze Tomato Spice accents. Float Chrome Green Light reflective light. Add the tassels using your liner brush. Tap in Tomato Spice in a circle. Tap Cinnamon on the left edge to shade. Tap Straw in the upper right hand corner of the tassels to highlight. Float Burnt Umber to the left of the tassels to add the cast shadows. Line the hat ties with Pigskin. Add Tomato Spice lines to the ties. Shade ties up by the hat with Burnt Umber. The bead is basecoated with Pigskin. Float to shade with Spice Brown, reinforced with Burnt Umber. Highlight bead with Straw.

Guitar
Use the same shade and highlight colors as the hat and paint as follows: Float in the first shade and highlight colors, walking it out where necessary. Add the second shades and highlights in the same manner as the first. Dampen the top of the guitar with water. Use a liner brush to swirl Pigskin in the dark areas, Straw in the middle value areas, and Straw + Custard (1:1) in the light areas, creating the texture. Transfer the details onto the guitar. Basecoat the hole with Black. Paint the center decor with Cinnamon. The knobs at the top of the guitar are painted with Black. Dampen the center decor and add swirls of Black. Add the strings with Rain Grey. Highlight the strings with Quaker Grey. Add glazes of Black Green to the darkest areas of the guitar. The reflective light is floated with Chrome Green Light.

Finishing
Varnish as stated in "Varnishing," page 89.

77

PATTERN

Frame Corner Pattern

SHADE PLACEMENT DIAGRAM

Lining Diagram

Enlarged Nose

Stippling Diagram

– Shades

HIGHLIGHT AND ACCENT PLACEMENT DIAGRAM

- Highlight
- Accents
- Reflective Lights

Enlarged Eye

81

Belle

Palette
Delta Ceramcoat® Acrylics: Adriatic Blue, Antique White, Black, Burnt Umber, Cape Cod Blue, Dark Burnt Umber, Dark Forest Green, Dark Night Blue, Drizzle Grey, Leprechaun, Maple Sugar Tan, Napthol Red Light, Old Parchment, Quaker Grey, Raw Sienna, Soft Grey, Spice Brown, Spice Tan, Straw

Surface
4 3/8"h x 9" dia. Round Wooden Box

Additional Supplies
Plastic wrap

Wood Preparation and Basecoating
Read the General Instructions, pages 89-92, before you begin to paint. Prepare the surface as stated in "Wood Preparation," page 89. Trace the design, page 86, onto tracing paper, then transfer the bear outline only onto the center of the lid. Basecoat the bear with Raw Sienna + Spice Brown (4:1). Basecoat the background with Dark Night Blue + Adriatic Blue (1:1) for the inner circle and Adriatic Blue for the outer circle. (Do not basecoat the blue colors under the bear; they will alter the color of the Raw Sienna mixture.) Transfer all remaining pattern lines. Basecoat the dress with Drizzle Grey. Line the details of the bear's face with Burnt Umber, then basecoat the nose and irises with Burnt Umber and the pupils with Black. The line work, stroke flowers, and leaves will be added after completing the bear. The bottom of the box is basecoated in Drizzle Grey with enough coats to evenly cover the box. Using a dampened, large sea sponge, sponge Adriatic Blue and Cape Cod Blue on the bottom of the box.

Painting Directions
Refer to the photos, pages 83-85, and the paint diagrams, pages 87-88, as you paint.

Bear
Dry brush the highlights on the bear with Spice Tan using a Cole Dry Brush, varying the size according to the area being painted. Dry brush the second highlights with Maple Sugar Tan + Spice Tan (4:1). Please note that each value change covers a smaller area than the previous one. Referring to the value placement diagram, float to shade the bear with Spice Brown, dry brushing and walking out the float were necessary.

Stippling
The stippling colors are, from dark to light, Spice Tan, Maple Sugar Tan + Spice Tan (2:1), and Maple Sugar Tan. Using a Cole Scruffy Brush, begin adding texture by stippling very lightly. Apply the color one value lighter than the area being worked. For example, in the dark areas, use Spice Tan. In the highlight areas, use Maple Sugar Tan.

Fur Texture
Line the fur using, from dark to light, Spice Tan, Maple Sugar Tan + Spice Tan (2:1), Maple Sugar Tan, and Maple Sugar Tan + Old Parchment (1:1).

Glazing the Fur
Glaze the dark areas of the bear again, using Burnt Umber, if they were lost. Now glaze Dark Burnt Umber only in the darkest areas of the bear. Glaze Napthol Red Light accents.

Eyes
Line the perimeter of the irises with Black. Float Quaker Grey on both edges of the pupils. When dry, place three or four small dot glints in the center of the pupils with Soft Grey. Add star shaped lines with Soft Grey in the upper left corners of the pupils. Add the final glints with dots of Antique White.

Nose
Shade the nose with Burnt Umber. Highlight the nose with Spice Tan, reinforcing the highlight with Maple Sugar Tan. Add the final glints with Antique White.

Dress and Bow
Dry brush the first shades with Quaker Grey + Adriatic Blue (7:1). Float on the first shades on the bow using the same colors. Dry brush the first highlights with Soft Grey. The headband and the bottom of the bow will need to be floated with Soft Grey. Float the second shades on the dress and bow with Quaker Grey + Black (8:1). The pattern lines on the dress are added, using from dark to light, Adriatic Blue, Adriatic Blue + Cape Cod Blue (1:1), and Cape Cod Blue. Thin these colors to an ink-like consistency. Using a #0 liner, apply the lines starting in the dark areas with the dark color, moving into the lighter colors as you move into the lighter areas of the dress. Add the flower to the bodice by lining it with Cape Cod Blue. Paint the center with Cape Cod Blue, also. Fill in the petals with Straw + Old Parchment (1:1). Very lightly dry brush the second highlights with Antique White. Flip float to reinforce, if necessary. Glaze the darkest areas with Quaker Grey + Black (4:1). Glaze the accents with Napthol Red Light.

Stroke Flowers and Leaves
Lightly transfer the flower and leaves onto the lid. Stroke the flowers on with a #3 round brush using Old Parchment + Straw (1:1). The stems and most of the leaves are painted with Leprechaun. For variation, stroke a few Dark Forest Green leaves and stems. The dots are Drizzle Grey.

Finishing
Varnish as stated in "Varnishing," page 89.

PATTERN

86

SHADE PLACEMENT DIAGRAM

▦ - Shades

HIGHLIGHT PLACEMENT DIAGRAM

- Highlights

General Instructions

WOOD PREPARATION

Sand the wood if necessary. Wipe the wood with a clean tack cloth. To apply sealer, use a large old brush or a sponge brush. Do not dampen the brush with water because it could cause the wood to warp. Simply fill the brush with sealer, then blot it on a paper towel. Working quickly from top to bottom, apply an even application of sealer. Look for any areas that have ridges built up and remove them with your finger or a clean brush. Allow the sealer to dry completely, then sand over it again lightly. This will remove any wood grain that has risen. Wipe again with a clean tack cloth. It should feel smooth. If there are any rough areas, repeat the sanding process.

BASECOATING

To basecoat, begin with a damp brush. Rinse the brush in water and blot it on a paper towel. Use as large a brush as possible to basecoat. Also, always use fresh paint. This will keep the application of paint smoother with less streaking. To load the brush, fill it with paint about halfway to the ferrule. Never completely fill the brush with paint; this will create ridges while basecoating and ruin your brush. To eliminate brush marks, always keep your brush laid at a 30° angle from the surface. This will allow the paint to flow evenly out of the brush, without digging up any paint. Begin at the top of the surface and work down. Work quickly, pulling the brush in even strokes. Take care not to build ridges. If any appear, simply use your finger to wipe the excess paint away. Do not go over areas once they have started to dry. This causes many problems. Once the first application of paint is complete, give it time to dry completely, then add a second or third coat. After each application of paint, it may be necessary to sand the surface lightly to get rid of any ridges that have built up. Remember to wipe the area with a clean tack cloth before applying another application of paint. The basecoat should be smooth and even, completely covering the background area.

MIXING PAINT

When mixing paint, follow the ratio of paint listed just like a recipe. The first number represents how many parts of the first color listed, the second number represents the second color, and so on. Use an equal measurement, such as one drop or the tip of a palette knife, to measure each part.

VARNISHING

Allow the finished project to cure for at least 24 hours. Gently wipe the project with a clean tack cloth so no residue from the cloth is left on the surface. Apply two to three thin coats of varnish, allowing proper drying time between coats.

PAINTING TECHNIQUES

ACRYLIC LAYERING TECHNIQUE

The technique used to paint the projects in this book is called the Acrylic Layering Technique. Multiple thin layers of each color are built up until they are smooth and even. Each application represents a step to creating form within an object. If the color is applied too heavy or unevenly, it will be too harsh. Take the time to build multiple, thin applications of each color and the end result will be more pleasing.

FLOATED COLOR

Being able to float well is the key to painting in acrylics. Practice is the only way this can be mastered. Water, fresh paint, and high quality brushes are needed for good floating. Dip the brush in water, then blot it on a paper towel. The shine on the hairs of the brush will fade away as the water is pulled out of the brush. Once the shine diminishes, it will be loaded with the proper amount of water. It should be wet enough to dampen the surface, but not so wet that a puddle can be formed. Add paint to the corner of the brush. Then, "work" the paint into the brush on a wax paper palette paper. Set the brush on the palette paper. Applying pressure, stroke the brush in the same place on the palette paper until a gradation of color is obvious. The color should gradate from a semi-opaque coverage on one end to clear water on the other end of the brush. If the paint has worked itself to the water side, a hard edge will result in floating. What appears on the palette paper is how it will appear on the surface. Therefore, continue blending the float on the palette paper until the desired effect is achieved.

FLIP FLOATS/BACK-TO-BACK FLOATS

These are usually used to apply highlights in the center area of an object. Keep in mind that it can be helpful to dampen the area first with floating medium to keep the flip float soft. Imagine a line in the center of the area to be highlighted. Place the loaded brush down on the right side of this imaginary line, float, then flip the brush over and float along the left side of this line. Sometimes it will be necessary to walk out the flip floats to cover a wider area. To accomplish this, simply walk out the strokes on the right side, then flip the brush over and walk out the strokes on the left side. Make sure a hard line does not form where the paint comes together along the imaginary line. Remember that the paint should meet, but not overlap.

GLAZING

Glazing is applying transparent color over a painting to add more dimension and interest. This technique is generally used to apply accents and/or to build greater values. The key to success is applying multiple thin layers of transparent paint. Load the brush, as if to float, with a small amount of paint. Stroke the brush back and forth on the palette paper until most of the paint is out of the brush. What remains is a transparent color. Apply as if walking out a float of color. Repeat if necessary. It is important not to rush this process, building multiple thin layers of transparent paint. With each layer, the color becomes more vibrant.

Floating and Glazing

STIPPLING

Stippling is used to created texture. Fresh paint, the amount of paint used, the brush pressure, and the amount of coverage are the key elements in stippling. I have designed a special brush for stippling called the Cole Scruffy. Dampen the brush, then blot it on a paper towel, pulling as much moisture out of the brush as possible. The brush will begin to open once the moisture is removed. To open the bristles even further, use your thumb and forefinger to pull the bristles. Do not use your fingernails; they will cause the ends of the brush to curl. Load just the tips of the bristles with paint. Pounce up and down on the palette paper until a light texture is created. Now lightly pounce this brush on the painting surface, using very little pressure and turning the brush with each pounce so that a pattern does not develop.

Stippling

LINE WORK

There are three things that make line work successful: good quality brushes, amount of pressure used on the brush, and proper paint consistency. The brush you use should always have a tip that comes to a point. Thin fresh paint to the consistency of cream. Load the brush, then roll the excess off on the palette, bringing the bristles to a point. Hold the brush in a position that is comfortable to you. The amount of pressure on the brush will determine the thickness of the line. Use light pressure for a thin line and heavier pressure for a thicker line.

LINING THE BEAR FUR

The bear fur is created using a two-step process using stippling and lining. Once the stippling is completed, use a #00 liner to add additional texture lines. Fill the brush as stated in "Line Work." Add short, crisscross lines within the fur and along the outside edges of the fur. These lines should be between $1/16"$ and $1/8"$ long. First determine the direction that you will be pulling the fur. Begin in the middle areas and work outward. Line the areas one to two values lighter than the areas being painted.

DRY BRUSHING

The key to success is proper loading and use of the brush. I use brushes that I designed specifically for this technique called the Cole Dry Brushes. The brushes are made with natural hog hair and are soft enough to dry brush without scratching the surface, yet they are durable so they withstand the scrubbing motion of dry brushing. To begin, load the brush thoroughly with paint, then wipe the brush on a dry paper towel, laying the handle back to a 30° angle. Rotate the brush as you remove the paint so that only a residue of paint remains. To paint, place the brush down where you want the greatest concentration of paint. Lay the brush back on its handle, keeping it at a 30° angle to the surface. This is easier if the brush is held further back on the handle or if your hand is off the table. Using a light pressure, begin slowly "scrubbing" the paint out of the brush in a small circular motion. Work the paint outward, allowing it to diminish so that there is a gradation of color. Work slowly, so that the application is smooth and even. It is important to start with a very soft touch and slowly increase the pressure on the brush as the paint begins to diminish. Sometimes it's necessary to repeat the application to attain the desired effect.

Dry Brushing

SPLATTERING

The amount of water in the paint and amount of paint in the toothbrush are the keys to successful splattering. Cover the areas within the design that should not be splattered. Thin the paint with water to a cream consistency. Load an old toothbrush with paint, then blot it on a paper towel to remove excess paint. Rub your thumb along the brush hairs to cause the paint to splatter. Test the splatter on palette paper before splattering the surface. This technique should produce very fine, consistent splatters. Use a dampened cotton swab to wipe away excess splatters.

WASH OF COLOR

To create a wash of color, the paint needs to be thinned to make it transparent. I find it useful to mix water + Color Float (3:1) when creating a wash. This helps the paint flow onto the surface with less streaking. The type of wash needed will determine the percentage of paint to water mixture. A light wash would have very little paint mixed into the water mixture, while a heavy wash would have more paint mixed in. Load the brush with the thinned paint, then blot it on a paper towel to eliminate puddles on the surface. Use as large a brush as you can control. Start at the top and work downward. Work quickly and do not stop painting unless you have reached an edge. Do not go over and over the same area, this will cause the wash to streak. In large areas, dampen the entire surface lightly with the water mixture, then apply the wash. This will eliminate streaking, but the wash may need to be repeated. Be certain the first wash is completely dry before adding a second wash.

Paint Chart

Delta Ceramcoat®	DecoArt™ Americana®	Plaid FolkArt®
Adobe Red	Antique Rose	Salmon + Cinnamon
Adriatic Blue	Uniform Blue + Charcoal Grey	Slate Blue
Antique Gold	Antique Gold	Yellow Ochre (AP)
Antique White	Buttermilk	Taffy + White
Black	Black	Licorice
Black Cherry	Burgundy Wine	Alizarin Crimson (AP)
Black Green	Black Green	Wrought Iron
Blue Haze	Blue Haze + White	Bluebell + Teal Green
Blue Wisp	Blue Mist	Summer Sky + Gray Mist
Bridgeport Grey	Slate Grey	Whipped Berry + Payne's Gray (T)
Burgundy Rose	Brandy Wine	Huckleberry
Burnt Umber	Asphaltum	Burnt Sienna + Burnt Umber (AP)
Butter Cream	Light Buttermilk + Buttermilk	Warm White + Taffy
Cadet Grey	Neutral Grey Toning + Buttermilk	Light Gray + Dapple Gray
Candy Bar Brown	Antique Maroon	Apple Spice + Huckleberry
Cape Cod Blue	French Grey/Blue	Settler's Blue
Chrome Green Light	Avocado + Evergreen	Old Ivy + Clover
Cinnamon	Burnt Orange + Burnt Sienna	Teddy Bear Brown + Autumn Leaves
Coral	Coral Rose	Salmon + Peach Perfection
Custard	Taffy Cream	Lemonade
Dark Burnt Umber	Burnt Umber	Burnt Umber + Burnt Sienna (AP)
Dark Forest Green	Evergreen + Plantation Pine	Thicket
Dark Night Blue	Prussian Blue + Black (T)	Payne's Gray (AP)
Dolphin Grey	Light French Blue	Amish Blue (D)
Drizzle Grey	Dove Grey + Grey Sky	Light Gray + Porcelain Blue
Eucalyptus	Hauser Med. Green + Celery Green	Hauser Med. Green + Bayberry + Med. Gray
Fiesta Pink	Blush Flesh (D)	Poppy Red + Salmon
Flesh Tan	French Vanilla	French Vanilla
Forest Green	Avocado + Evergreen	Old Ivy
Fruit Punch	Antique Rose + Cadmium Red	Christmas Red + Strawberry Parfait
Golden Brown	Honey Brown	English Mustard

(D) Slightly darker
(T) Add just a touch of color
(AP) Artists' Pigment
(L) Slightly lighter

Paint Chart

Delta Ceramcoat®	DecoArt™ Americana®	Plaid FolkArt®
Gypsy Rose	Gooseberry Pink + Brandy Wine	Rose Garden + Promenade
Hammered Iron	Neutral Gray + Avocado (T)	Dapple Gray
Hippo Grey	Neutral Grey	Medium Gray
Hydrangea Pink	White + Spice Pink	White + Calico Red
Ivory	Sand	Taffy
Leprechaun	Jade + Forest Green	Mystic Green
Lichen Grey	Driftwood	Barn Wood
Light Ivory	Light Buttermilk	Warm White (AP)
Maple Sugar Tan	Moon Yellow (L)	Buttercrunch
Maroon	Burgundy Wine (D)	Burgundy
Mudstone	Driftwood (L)	Barn Wood (L)
Napthol Crimson	Napthol Red	Christmas Red
Napthol Red Light	Primary Red	Calico Red
Navy Blue	Ultra Blue Deep	Cobalt + Midnight
Nightfall Blue	Uniform Blue (L)	Denim Blue
Ocean Reef Blue	True Blue + White	Cerulean Blue + Cobalt
Old Parchment	Moon Yellow	Sunflower + Buttercup
Orange	Cadmium Orange	Red Light (AP)
Payne's Grey	Payne's Grey	Payne's Gray + Prussian Blue (T)
Periwinkle Blue	Country Blue	Light Periwinkle
Pigskin	True Ochre + Raw Sienna (T)	Yellow Ochre + English Mustard
Pine Green	Evergreen + Midnite Green	Thicket + Old Ivy
Pink Angel	Dusty Rose + White	Promenade (D)
Pink Parfait	Boysenberry Pink + White	Pink
Purple	Dioxazine Purple	Purple
Purple Dusk	Country Blue + Dioxazine Purple	Periwinkle + Purple Lilac
Quaker Grey	Dove Grey + Neutral Grey (T)	Light Gray + Ice Blue
Queen Anne's Lace	Sand + Toffee	Georgia Peach + Taffy
Rain Grey	Slate Grey (L)	Porcelain Blue + Black
Raw Sienna	Raw Sienna	Yellow Light + Terra Cotta
Red Iron Oxide	Red Iron Oxide	Light Red Iron Oxide (AP)

(D) Slightly darker
(T) Add just a touch of color
(AP) Artists' Pigment
(L) Slightly lighter

Paint Chart

Delta Ceramcoat®	DecoArt™ Americana®	Plaid FolkArt®
Rose Petal Pink	Pink Chiffon	White + Ballet Pink
Rouge	Blush Flesh (L)	Poppy Red + Christmas Red
Sandstone	Desert Sand	Clay Bisque
Soft Grey	White + Dove Grey + Grey Sky	Gray Mist + Dove Gray
Spice Brown	Milk Chocolate	Nutmeg
Spice Tan	Antique Gold + Sable Brown	Honeycomb
Storm Grey	Slate Grey + Black	Charcoal Gray
Straw	Golden Straw	Buttercup
Sunbright Yellow	Whtie + Lemon Yellow	Lemon Custard + White
Tangerine	Tangelo Orange	Autumn Leaves
Tide Pool Blue	French Grey/Blue + White	Porcelain Blue
Tomato Spice	Tomato Red	Red Light + Apple Spice
White	White	White
Wild Rose	Raspberry	Raspberry Sherbert
Wisteria	Lavender + Cranberry Wine	Plum Chiffon + White

(D) Slightly darker
(T) Add just a touch of color
(AP) Artists' Pigment
(L) Slightly lighter

Wood Sources

- Pearl, page 56

Custom Wood by Dallas Fisher
2204 Martha Hulbert Drive
Lapeere, MI 48446
(800) 251-7154

- Leilani, page 4
- Barney, page 20
- Rosie, page 48

Smooth Cut Wood
13158 Donald Road N.E.
Aurora, OR 97002
(503) 678-1318

- Davy, page 36
- Carlos, page 74
- Sam, page 62

Viking Woodcrafts
1317 8th Street S.E.
Waseca, MN 56093
(800) 328-0116

- Angel, page 10
- Belle, page 82
- Holly, page 28

Woodcrafts, Inc.
Highway 67
Bicknell, IN 47512
(812) 735-4820

Credits

Production Team:

Technical Editor - Jennifer S. Hutchings

Senior Graphic Artist - Chaska Richardson Lucas

Graphic Artists - Ashley Carozza and Karen Allbright

Photography Stylist - Jan Nobles

Leisure Arts, Inc. grants permission to the owner of this book to photocopy patterns for personal use only.

The information in this publication is presented in good faith, but no warranty is given, nor results guaranteed. Since we have no control over physical conditions surrounding the application of information herein contained, Leisure Arts, Inc., disclaims any liability for untoward results.

©2005 by Leisure Arts, Inc., 5701 Ranch Drive, Little Rock, AR 72223-9633. All rights reserved. This publication is protected under federal copyright laws. Reproduction or distribution of this publication or any other Leisure Arts publication, including publications which are out of print, is prohibited unless specifically authorized. This includes, but is not limited to, any form of reproduction or distribution on or through the Internet, including posting, scanning, or e-mail transmission.

If you enjoy decorative art and sharing painting ideas with others, you should join the **Society of Decorative Painters**, a unique and exciting organization of enthusiastic painters. For more information, write to: SDP, 393 N. McLean Blvd., Wichita, KS 67203-5968. Or call (316) 269-9300 or visit their website at www.decorativepainters.org.